Picasso

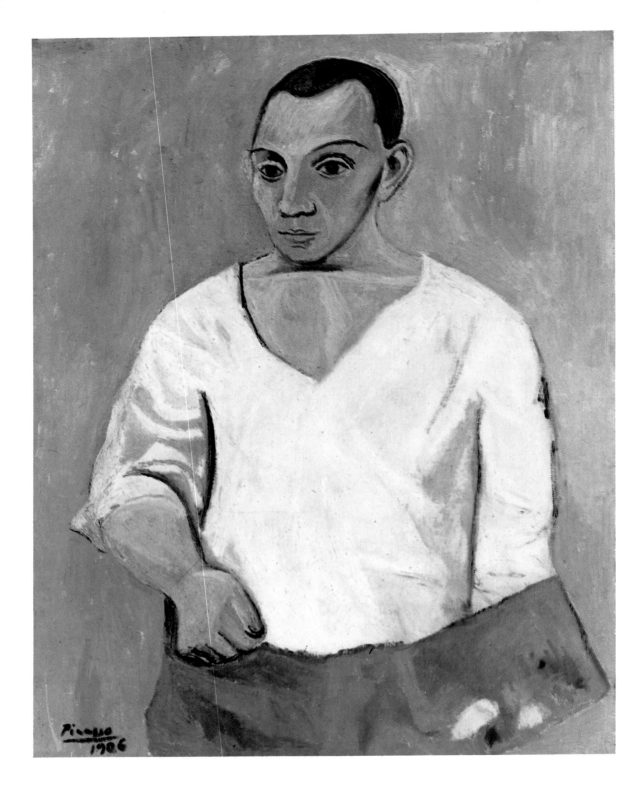

Ingo F. Walther

PABLO PICASSO
1881–1973

Genius of the Century

BARNES
& NOBLE
BOOKS
NEW YORK

FRONT COVER:
Guitar (detail), 1913
Papiers collés, charcoal, India ink and chalk on paper, 66.4 × 49.6 cm
New York, The Museum of Modern Art,
Nelson A. Rockefeller Bequest

ILLUSTRATION PAGE 2:
Self-Portrait with a Palette, 1906
Oil on canvas, 92 × 73 cm
Philadelphia, Philadelphia Museum of Art,
A. E. Gallatin Collection

BACK COVER:
Pablo Picasso with bread fingers
Photograph by Robert Doisneau
Vallauris, Villa La Galloise, 1952

This edition published by Barnes & Noble Inc.,
by arrangement with Benedikt Taschen Verlag GmbH
1996 Barnes & Noble Books

© 1996 Benedikt Taschen Verlag GmbH
Hohenzollernring 53, D-50672 Köln
© 1995 VG Bild-Kunst, Bonn for the illustrations
English translation: Hugh Beyer

Printed in Germany
ISBN 0-7607-0115-6
GB

Contents

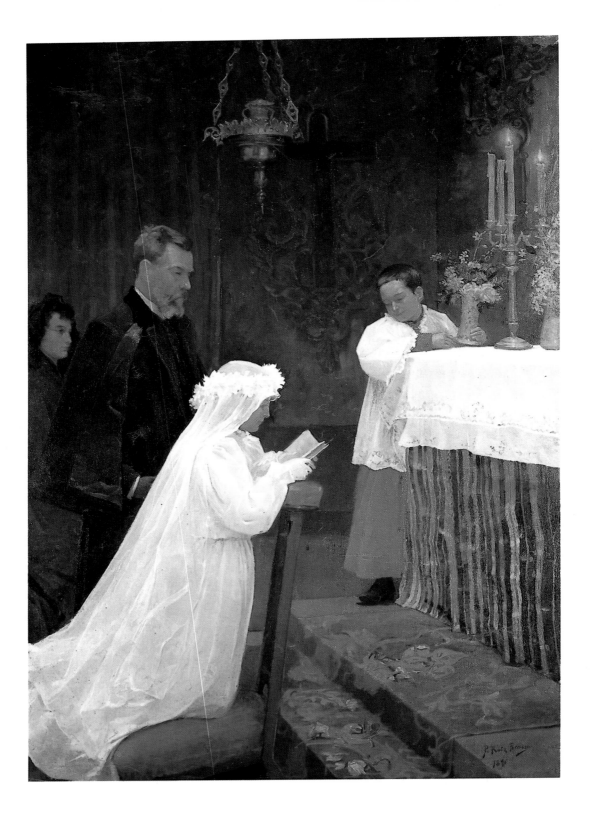

Childhood and Youth
1881 — 1901

There can be no doubt that, both in quantity and in quality, Picasso's art is unparalleled and that his paintings, sculptures, etchings and ceramics reveal the hand of someone who deserves to be called Genius of the Century. But would he ever have reached such heights if he had not been the kind of person he was? He may have been revolutionary, he may have introduced countless innovations and he may have broken with a tremendous number of outmoded traditions, but none of this is really enough for a person to be regarded as a genius. There must have been something else, a certain charisma, something that fascinated and enchanted both critics and admirers alike. And Picasso did indeed have an abundance of it.

It is the task of critics and art historians to convey the meaning of his art, but it is rather difficult to draw a clear dividing line between such academics and a second group of people who have been equally important in giving us an idea of why he was such a genius: these are relatives, friends and contemporaries – and, of course, biographers, too. These are the people from whom we can learn about Picasso as a person. Without them, it would be impossible for us to understand either Picasso himself or the influence which he had on subsequent generations of artists. We would not even be able to understand his popularity. Also, they provide a link between Picasso as a person and artist, on the one hand, and his public, on the other. And when we say public, then that includes both enthusiastic admirers and scornful sceptics.

Picasso's biography really started quite a long time before he was even born. Biographers believed that there must have been sources outside the artist to account for the incomprehensible, the unimaginable, the genius in him. It therefore seemed obvious to research into the past. And they did indeed find traces as close as his parents' generation: Picasso's father, Don José Ruiz Blasco, was a painter, albeit a rather mediocre one. This paternal branch of his family can be traced back as far as 1541. Roland Penrose, probably one of Picasso's best-known biographers, describes this ancestral line: „Again and again, his ancestors show dedication, toughness, courage, open-mindedness in matters of art, and honesty in matters of religion." All of these are qualities which apply to the most famous man in the line: Pablo Ruiz Picasso. His maternal line has also been researched into. Pablo inherited

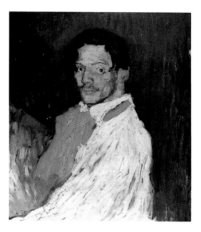

Self-Portrait: Yo Picasso, 1901
Oil on canvas, 29 x 23¾ in.
Private collection

„If you know exactly what you're going to do, what's the good of doing it? Since you know, the exercise is pointless. It is better to do something else." PICASSO

First Communion, 1895/96
Oil on canvas, 65 ¼ x 46 ½ in.
Museo Picasso, Barcelona

at least his outer appearance from his mother Doña Maria Picasso y López, and there were in fact two painters among her ancestors.

It hardly comes as a surprise when we learn that the first of countless Picasso legends starts with his birth. The midwife had given him up for dead and gave all her attention to his mother. It was thanks to Don Salvador's presence of mind that Pablo was saved from suffocation. Don Salvador was his uncle and a qualified doctor. His method was both simple and effective: he blew some cigar smoke into the face of the little future genius - and that made him cry. This happened at 11.15 p.m. on 25th October 1881.

Picasso himself used to enjoy telling this legend, and so do his biographers. The story appeals to them because it shows Picasso's first encounter with death, even shortly after he was born, and it shows his victory over it, even though with somebody else's help. People used to admire his vitality even when he was ninety. This vitality was certainly the most important aspect of his art, and it had been there from birth.

Picasso spent the first ten years of his life in Málaga, where he was born. His family were far from rich. Father was the curator of the town museum and an art teacher at the "Escuela de San Telmo", and it was often difficult to make ends meet. When he was offered a better-paid job in the north of Spain, he accepted it gladly, and the Picassos moved to the provincial capital of La Coruña on the Atlantic coast, where they lived for the next four years.

His father was in fact the first person to encourage his son's talents, although he was at first rather more concerned about Pablo's progress at school. Later in his life, Picasso used to tell that he had really only been interested in the way the teacher wrote numbers on the blackboard. He would copy their shapes, but had absolutely no interest in the mathematical problem. He often wondered how he had ever managed to learn basic arithmetic. Instead, he used to make drawings whenever possible. To him this seemed to be the only way in which he could express himself appropriately.

So the genius refused to follow the beaten track of traditional education and took his artistic career into his own hands. At first his father served as the example, but as soon as Picasso had reached 13, he had already caught up with him. There was a decisive moment in his life and in the relationship between father and son, which was summarised by Picasso with the laconic words: "So he handed me his paint and his brush and never painted again." Picasso had really only obeyed his father's instructions and finished off the feet of some pigeons. However, these had turned out so true to life that father handed his tools over to his son, thus recognising that young Pablo had become a mature artist.

And when he passed his entrance examination at "La Lonja" school of art in Barcelona, there was a similar outcome. His father had been offered a professorship there and had moved to Barcelona in 1895. Due to his influence, his son was allowed to skip the beginner's course. But before Pablo was allowed on an advanced course in classical art and still life, he had to submit a project file within one month. But little Pablo handed in his work after only one day. Not only that, but he had done better than senior students in their final exam projects.

Portrait of Pedro Mañach
Oil on canvas, 29 ½ x 26 ½ in.
National Gallery of Art, Washington

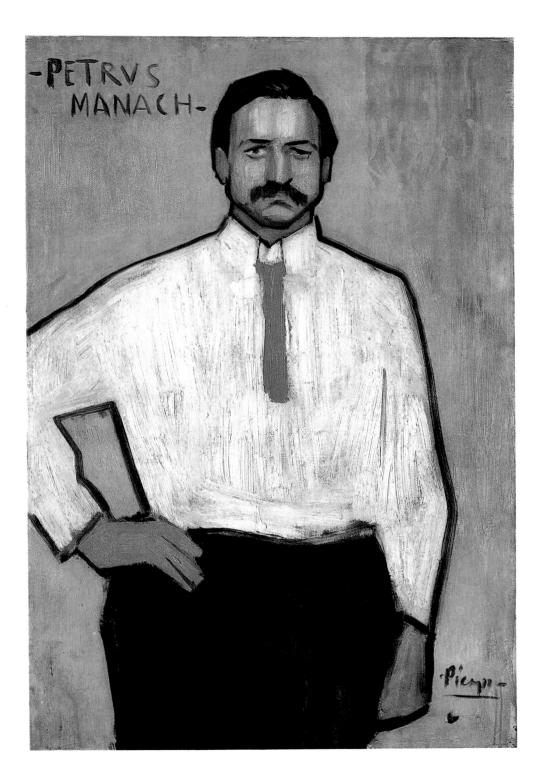

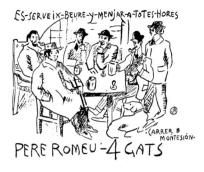

ES-SERVEIX-BEURE-Y-MENJAR-A-TOTES-HORES

PERE ROMEU - 4 GATS

**Study for a Poster for "Els Quatre Gats"
(The Four Cats), 1902**
From left to right: Romeu, Picasso,
Roquerol, Fontbona, Angel F. de Soto,
Sabartés
Ink drawing, 12 ¼ x 13 ⅜ in.
Private collection, Ontario

"I can say it with pride. I have never
regarded painting as an art merely for the
purpose of entertainment and
amusement. As my pen and my paint do
happen to be my weapons, I wanted to use
them to penetrate deeper and deeper into
a knowledge of the world and of people,
so that this knowledge might set all of us
more and more free each day ... Yes, I am
aware that I have been fighting with my
art like a true revolutionary ..." PICASSO

The Absinth Drinker, 1901
Oil on cardboard, 26 x 20 in.
Melville Hall Collection, New York

He was a prodigy. With hardly any formal training, he satisfied the
requirements of a renowned academy at the age of 14. Gertrude Stein,
who later became his mistress and patroness, saw in him a true master: it
may be true in most cases that no man is born a master of his craft, but
Picasso was. "He used to paint," she wrote, "from a very early age, and
his paintings were not childish endeavours but the paintings of a born
painter." Picasso specialists regard it as an important clue to his genius
that he painted like an adult when he was a child, but there was still a
childlike element in his adult paintings. This is why Paul Eluard started his
London lecture in 1951 with the words: "Picasso, the youngest painter in
the world, will be 70 today."

Long before his apprenticeship was over, Picasso joined the ranks of
the most distinguished painters of Barcelona. His first big oil painting of
1895/6 (p. 6) was shown together with paintings by Santiago Rusiñol and
Isidro Nonell at what was then the most important exhibition ever held in
Barcelona. He chose a religious topic, but instead of painting a scene
from the Gospels, he showed an extremely significant incident in the life
of a Christian. This final acceptance into Christian fellowship was chosen
as an occasion for a picture illustrating family history. Not only did the
choice of the topic satisfy all academic demands for sugary emotionalism,
but the realism of the painting also met the demand for something
conventional. Picasso was, of course, soon to dissociate himself from
such academic pedantry.

After a short summer holiday in Málaga in 1897 he moved into his
new studio in Madrid and joined the Academy of San Fernando, one of
the best-known academies in Spain. But his numerous visits to the Prado
were to become far more important for his subsequent development. At
first he copied the old masters and tried to imitate their style; but later
they were to serve as themes that would give him fresh ideas for original
paintings of his own, and he would re–arrange them again and again in
different variations.

Picasso's time in Madrid, however, came to a sudden end. At the
beginning of June he contracted scarlet fever and had to return to
Barcelona to get better. Hardly had he arrived, but he became restless
and went to the mountain village of Horta de Ebro with his friend Manuel
Pallarés. Whereas in Madrid he had begun to withdraw from the
influence of the academy and his family, Picasso found his own self in this
remote Pyrenes village. In spring 1899 he returned to Barcelona full of
ambitious plans. He had become open-minded towards new
developments in Spanish art and was seeking contacts with their most
prominent representatives. They used to meet in the artists' pub "Els
Quatre Gats" (The Four Cats). This is where Picasso got to know the
modernists Rusiñol and Nonell whose style he imitated successfully. They
were influenced by French Art Nouveau and the English pre-Raphaelites.
The older artists soon had great respect for him, and in 1900 he was given
permission to hold his first exhibition in the artists' pub.

He was so enthusiastic about these new directions in art that he
wanted to go to Paris which, at the time, was the most significant centre
for all artists. Paris was where he would find the actual origins of Spanish
modernism, which until now he had only known second-hand. He was

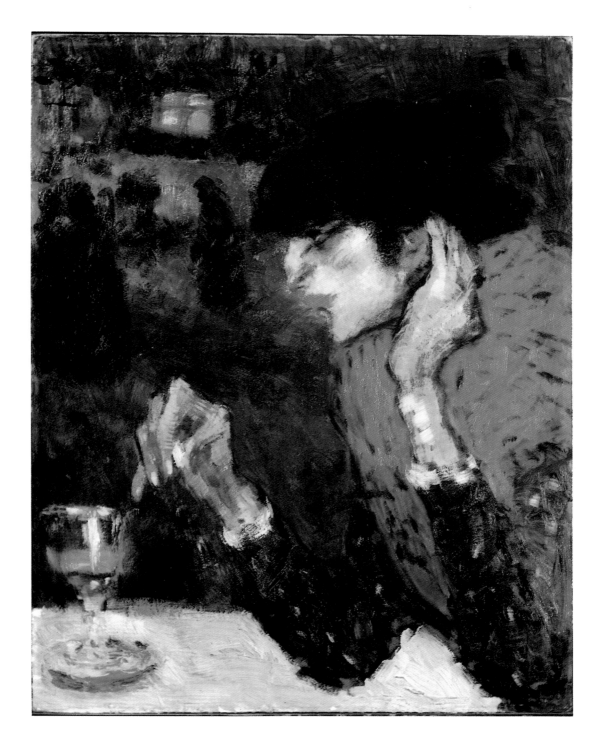

particularly attracted to Henri de Toulouse-Lautrec, but he also saw paintings by Paul Cézanne, Edgar Degas and Pierre Bonnard in art dealers' shops. In Paris, at last, he could feel that freedom from conventions and traditions which his stormy nature had been longing for. This is where he found the necessary openness for his artistic experiments.

Pedro Mañach, a young curator of a gallery, was so enthusiastic about Picasso's paintings that he offered him a contract immediately. Picasso did not hesitate. He was paid 150 Francs per month for delivering a few paintings regularly. Thus, for the time being, he managed to overcome his worst financial worries. Picasso was so exuberant that he painted several portraits of his first curator (p. 9).

When he went back to his native Spain, it was only for a very short time. He had become alienated from his parents. Their middle-class preconceptions made it impossible for them to understand either their son's Bohemian attitudes or the lack of control in his art. They felt that their hopes for Pablo to become an academic painter of local significance had been disappointed. What mattered to them was that their son would not make their name famous. But they were wrong. After his clashes with his parents, Picasso also had to give up his ambitious plans to publish an art magazine. The project failed after only a few editions. Disappointed with the provincialism of his native country, he returned to Paris in May 1901.

Picasso's development into a mature artist began with an academic education; but by the time he was 16 he had already learned everything there was to learn. When he turned to contemporary Spanish art, he did so with the ambition, as he wrote in a letter, of being more modernist than the Modernists themselves. And he achieved his aim. Only Paris could offer any challenge during his years of training, and it took him less than a year to acquaint himself thoroughly with the latest artistic techniques.

He created pastel drawings with the delicate shades of Degas (p. 13), the motif of stylish worldliness as chosen by Toulouse-Lautrec, and the freedom of Picasso. It was paintings such as "The Absinth Drinker" (p. 11) that heralded his Blue Period. All alone, she sits at her table and talks to the glass in front of her. But melancholy has not yet become the theme of his art. In this picture melancholy appears to be swept away by the overwhelming presence of vivid colours, colours which dissolve all contours.

Picasso had not found his own style yet. But the time of rubbing his shoulders with other artists in order to find his own way was approaching its end. He was about to enter his Blue and Rose Periods, the first artistic phases in his life as an autonomous artist. His training period had come to an end: Picasso had become Picasso.

Woman in a Blue Hat, 1901
Pastel on cardboard, 24 x 19 ⅝ in.
Galerie Rosengart, Lucerne

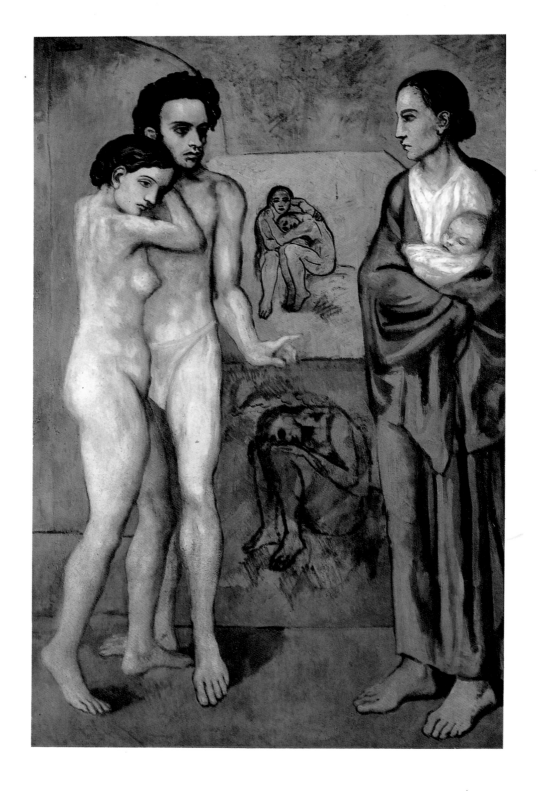

The Blue and Rose Periods
1901 – 1906

It began with a masterpiece. The Blue Period started with the painting "Evocation – The Burial of Casagemas" (p. 16). It marked the end of a friendship and the beginning of a new creative phase in Picasso's life. There was nothing in the next six years that would have reminded anyone of this former enthusiasm for the uninhibited lifestyle of Paris. Years before, when Picasso and his friend from Barcelona, Carlos Casagemas, had visited Paris for the first time, the two painters were rather shocked, but they also experienced a sense of freedom when they saw couples embracing each other passionately in public and watched risqué dances in night clubs. Such things would have been unimaginable in conservative Spain.

The two artists had allowed themselves to be seduced by the unrestrained life of the metropolis. But now that Picasso was returning to Paris without his friend, all the drunkenness had left him and his euphoria had made room for a more sober disposition.

His friend had shot himself in a Parisian café because the girl he loved, a model called Germaine, had rejected him. This had happened in February 1901, but Picasso's Blue Period did not start until the summer of the same year. In the meantime he had tried to come to terms with his friend's death through his art. For Picasso art was more than the language he talked – and he talked a lot – but he also used it as a means of understanding the world, coming to terms with it, absorbing it. And understanding meant observing and perceiving. This approach provides us with a clue to his words: "I began to paint in blue, when I realised that Casagemas had died." The Blue Period was a direct result of his friend's death. But it could not start until Picasso perceived the incomprehensible as something real and true. When he had finally reached an understanding of it through his art, there were three pictures of his friend laid out for burial. For many years to come, these were to be the last paintings in bright, glowing colours. He used them, as it were, like quotations: Picasso was quoting Vincent van Gogh who, like Casagemas, had committed suicide, and he was quoting in the same tragic style of that great 19th century artist.

Shortly after these sketches, Picasso started working on sketches for his painting "The Burial of Casagemas". In his painting he arranged a burial for his friend that would have befitted a saint, though his version

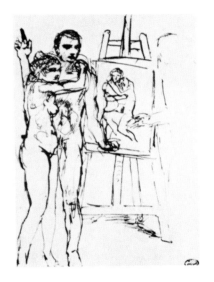

Study for "La Vie", 1903
Indian ink, 6 ¼ x 4 ⅜ in.
Musée Picasso, Paris

La Vie (Life), 1903
Oil on canvas, 77 ¾ x 50 ⅝ in.
Cleveland Museum of Art, Cleveland

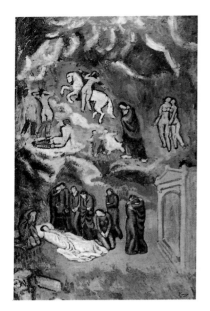

Evocation – The Burial of Casagemas, 1901
Oil on wood, 59 x 35 ½ in.
Musée d'Art Moderne de la Ville de Paris

"I'm no pessimist. I don't loathe art because I couldn't live without devoting all my time to it. I love it as the only end of my life. Everything I do connected with it gives me intense pleasure. But still, I don't see why the whole world should be taken up with art, demand its credentials, and on that subject give free rein to its own stupidity. Museums are just a lot of lies, and the people who make art their business are mostly impostors." PICASSO

The Tragedy, 1903
Oil on wood, 41 ½ x 27 ⅛ in.
National Gallery of Art, Washington

was rather more secular, if not atheistic. Instead of angelic choirs which usually surround the white steed that leads the dead person's spirit into heaven, there were prostitutes gathered on the clouds that used to be holy, clad in no more than their stockings. Picasso is granting his friend all those ecstatic delights in the heavenly spheres which he had to miss out on when he was alive. In the meantime his near and dear ones are gathered round Casagemas' dead body and moaning for him with pathetic gestures; Picasso is one of them. It was grief that made him create this picture. His encounter with death was a decisive turning point in his life, and there are subtle suggestions of death in all his paintings of the Blue period.

Casagemas' suicide coincided almost precisely with Picasso's visit to Toledo where he saw El Greco's painting "The Funeral of Count Orgaz". This picture served as a model. But El Greco's influence on Picasso was more than a matter of composition. There were also certain stylistic idiosyncrasies in El Greco's paintings which reflected exactly the same sentiments that Picasso wanted to express. Human bodies are stretched, elongated, to underline the idea that they have passed into a different world. El Greco, who was a Christian, used these distorted proportions to point to the saintliness of the people in the pictures and the supernatural significance of the scenes he painted. In Picasso's art, on the other hand, this quality of remoteness does not point to any divine sphere whatsoever; rather, his figures are detached from the world because they are poor and sick. Another stylistic device which Picasso borrowed are the cloudy streaks of colour that permeate the background. They serve to lend dramatic pungency to the scene and lend an air of otherworldliness to the space in which the figures move.

Casagemas' death had caused Picasso to paint this monumental picture, and the choice of the theme also explains why he chose a predominantly blue tinge. Blue seemed to be particularly suitable to express his feelings of sadness and grief. He continued to use this colour for over four years, and his pictures became more and more monochrome. His later paintings show no more than a very slight hint of green or red. The choice of colour has become an independent stylistic device, signalling above all that the pictures are no mere reproductions of reality. It lends unity to a whole group of paintings and also alludes to a number of series of paintings by Claude Monet, paintings which were thematically linked. The continuous stylistic changes of Picasso's training years have come to an end. He has stopped reacting to each and every new influence and has found his own style. Blue has become the first and unmistakeable trademark of his art.

But Picasso was still far from famous, and only very few people knew this young twenty-year-old Spaniard. He was still living and working in the poorly furnished top-floor flat that Mañach had found him. Casagemas had used to work there, and this is where the picture of his funeral was painted. There was very little space, and even after the picture was finished it served as a kind of painted screen. Behind it Picasso used to hide that creative chaos with which he surrounded himself wherever he went. This was his way of taking possession of a place, and it did not change even when he moved into spacious villas. He found

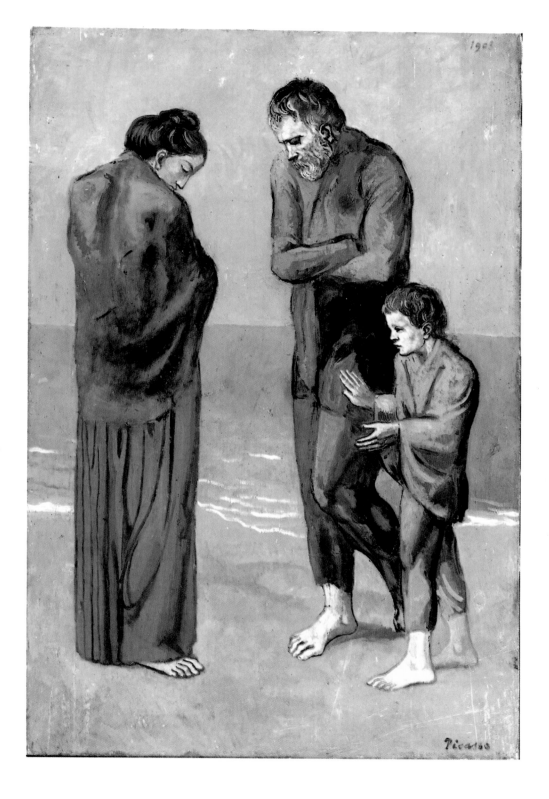

disorder stimulating, and he would start philosophising whenever he talked about the right organisation of proper chaos.

Not many pictures were produced during that time; as before, Picasso was often seized by fits of restlessness. Through his life he was constantly on the move, though later it was no longer a matter of deciding between home and self-imposed exile. He went to Barcelona again, but only stayed for a very short while, then returned to Paris, but travelled back to Spain again in spring 1903.

Eventually he settled down in Barcelona for a whole year and began to work with fresh energy. One of his first pictures was the allegorical painting "La Vie" ("Life", p. 14). Picasso had been building up to it with innumerable sketches. There is nothing spontaneous in it, nothing superfluous, everything seems to have been premeditated, though that does not necessarily make it comprehensible to the person looking at it. The confidence with which Picasso presents his topic makes the onlooker feel insecure. Where does the scene take place? Perhaps in the artist's studio, as suggested by one of his sketches (p. 15)? But the painter's easel, which was in the sketch, seems to have disappeared from the finished painting. The crouching figure squatting in the lower half of the painting can be understood as a picture within the picture and points to an artist's studio. This puts the smaller scenes of the centre of the painting on a second level of reality, which separates the standing figures from one another. Thus Picasso creates an impression of disjointedness, the individual elements are not related to one another, the figures just stand side by side, as if they had been added one by one. The picture consists of four large units, symbolising four different forms of existence. There is a lonely man who, without anybody's love, has only got himself to fall back on, there is a couple embracing each other, there is a mother who loves her child, and she faces the man and the woman who embody carnal love. (The man is another portrait of Picasso's friend, the painter Casagemas). Life is defined as coming between the loss of love and its fulfilment.

The Blue Period began with the death of Casagemas, who committed suicide because of his unrequited love. Although the following pictures are not explicitly about death, they are nevertheless about loneliness or the absence of love. "The Tragedy" (p. 17) illustrates this point. It shows a family without intimacy, people without life, frozen like statues. There is nothing in their environment that might give hope for an end of their isolation from one another. Only the child is making some kind of tentative gesture and is still keeping his head up. The figures are all wrapped up and seem to be trying to hide in their garments; however, they are unable to hide their bare feet, symbols of their poverty. In pictures like these Picasso shows unconcealed pathos.

Like the figures in his pictures, Picasso himself experienced poverty and loneliness, although the latter never lasted very long. Eventually he packed all his belongings into boxes and moved to Paris for the fourth time. This was his final decision for France. His new home was one of the centres of Bohemian lifestyle in Paris, a dilapidated artist's studio in the Rue Ravignan in Montmartre which was called "Bateau-Lavoir" (laundry boat) by Max Jacob, a poet friend of Picasso's. It was in this rather strange

Woman with a Crow, 1904
Charcoal, pastel and water-colour on paper
25 ½ x 19½ in.
Toledo Museum of Art, Toledo

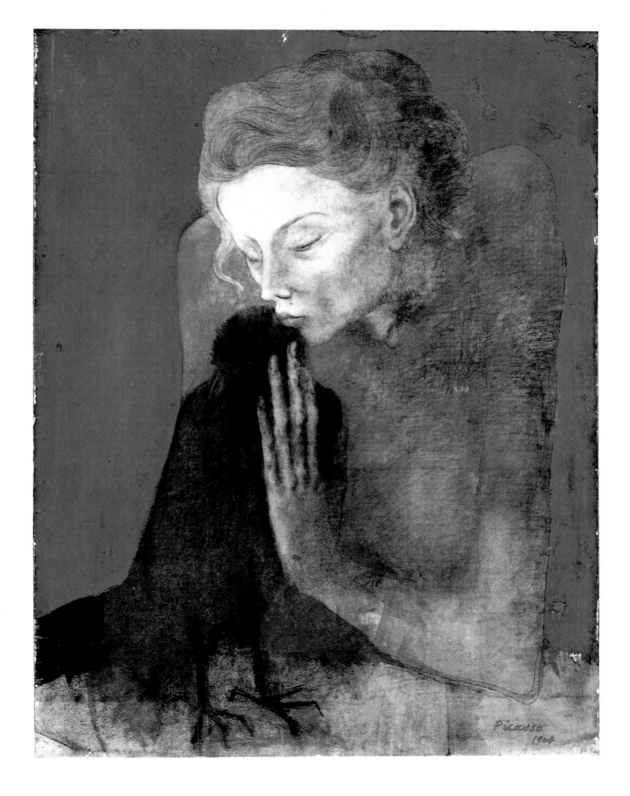

Acrobats' Family, 1905
Pencil and charcoal, 14¾ x 10½ in.
Musée Picasso, Paris

"When you come to think of it, there are very few themes indeed. They are constantly repeated by everyone. Venus and Eros become the Virgin Mary with her child, then Mother and Child, but it is always the same theme. It must be wonderful to invent a new one. Van Gogh, for instance. An everyday thing like his potatoes. To have painted that – or his old boots! That was really something." PICASSO

Tumblers (Mother and Son), 1905
Gouache on canvas, 35 ½ x 28 in.
Staatsgalerie, Stuttgart

abode that he happened to meet Fernande Olivier, the first girl who shared his life for any length of time. Although she did nothing to reduce his perpetual financial problems, she was certainly extremely talented when it came to buying something on credit at the grocer's round the corner. And considering that Picasso was not naturally inclined to be sedentary, it was certainly to her credit that she succeeded in making him settle down. Picasso was said to have kept up his relationship with "la belle Fernande" for seven years. He would even have married her, because he was quite open-minded in this matter, had she not persisted in refusing to take this step. Even Picasso's father Don José could not believe that Fernande was so stubborn and advised his son to be more persistent. However, neither of them knew that Fernande was married already.

Fernande, Picasso and the other people who lived in the "Bateau-Lavoir" used to meet in the artists' pub "Le Lapin Agile" (The Agile Rabbit). From time to time they were joined by the poets Guillaume Apollinaire and Max Jacob. The landlord was called Frédé. What made him and his café so attractive was the fact that he accepted pictures as payment. Thus he had acquired a stately collection of pictures, including, of course, one by Picasso: "At the Lapin Agile", a composition that dated back to the time when Picasso was inspired by Toulouse Lautrec, with Picasso as a harlequin and Frédé as a guitar player.

The picture "Woman with a Crow" (p. 19) shows Frédé's daughter. She is kissing the bird, and her thin, elongated fingers cover its breast. Her bright face is no more than a pencil-drawing, the white paper shining through the gentle pencil lines, thus creating the effect of pale skin. A soft light seemes to be stroking her face, emphasizing her beautifully delicate features. A strand of her lovingly chiselled hair curls gently round her temple. The black bird, on the other hand, lacks all grace, it is just an expanse of black with awkward feet protruding from it. Only the background is still blue. Instead, her slim, graceful body is covered by a gentle shade of pink, sometimes almost amber in colour. In this transition period from blue to pink Picasso revels in his own mature expertise as a painter as if he were paying homage to Beauty.

There is only a touch of melancholy left now. His romantic pessimism is no longer bitter, but seems to have acquired a pleasantly sweet quality, like a delicious luxury, enjoyable to indulge in. This can be seen in his painting "Mother with Child" (p. 21). Here we see two acrobats who have just come back from their performance, the woman's son still wearing his costume. The mother has draped a large piece of cloth round herself, her hair is in a bun and decorated with a flower. Her sorrow seems insignificant compared with her classical features, and so does the scantiness of the meal in view of the delicate way in which the plate has been painted. In Picasso's Blue Period the isolation of the figures was reflected in the smoothness of the paint on the canvas, which made them seem distant. Now, however, there is only a very thin coat of paint, and there is no impression of coldness or poverty whatsoever. The paint has been applied very lightly, which gives the picture an air of refinement. Poverty has its beautiful side.

So it is hardly surprising that these paintings later became some of

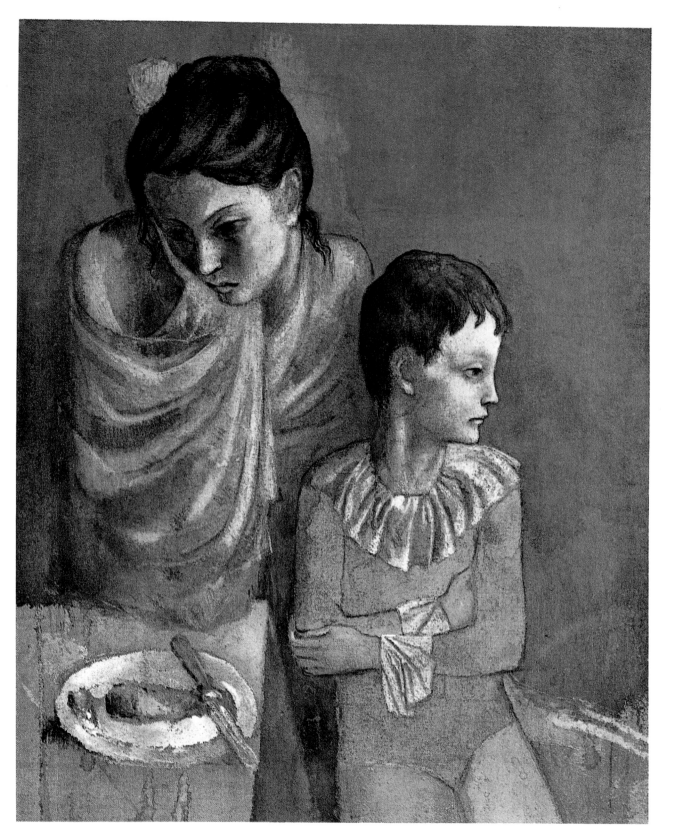

Mother with Child, 1904
Pencil, 13 ⅜ x 10½ in.
Fogg Art Museum, Harvard University,
Cambridge (Massachusetts)

Girl in a Chemise, about 1905
Oil on canvas, 28 ¾ x 23⅜ in.
Tate Gallery, London

his most expensive ones. This is summed up in John Berger's aptly cynical comment: "The rich enjoy thinking of the loneliness of the poor: it makes their own loneliness appear less fatal. This is one of the reasons why the pictures of this phase later became so popular with the rich." Although at this stage Picasso had already had a number of exhibitions in Barcelona and Madrid and had even managed to sell quite a few pictures, the real breakthrough was still to come. It was not to happen until after his Rose Period, when more and more art dealers began to take an interest in his art. At this stage he was still keeping his paintings in stock.

One of them was his picture "Woman in a Chemise" (p. 23). Ever since his beginnings in Barcelona, Picasso had been taking great delight in portrait work. Apart from numerous self-portraits in pencil, ink and oil, he had started off by painting his own family, his mother and father, his sisters, his aunt Pepa, and then later his friends and colleagues, Soler the tailor, Celestina the one-eyed owner of a brothel, and the art-dealers. His interest in this genre was no mere coincidence. After all, it demanded a certain closeness between the painter and his object. In 1905, when his Blue Period was over, his pictures had stopped speaking of loneliness and isolation. On the contrary, the woman's whole posture has an air of self-confidence: her head turned slightly, looking straight ahead, she is standing perfectly upright, with her arms suspended in a relaxed way. It is true, there were also nude figures in his Blue Period, but they were hardly attractive and had none of that erotic radiance that emanates from this woman in a chemise. And she certainly has a lot of this, mainly because of her tiny transparent garment which reveals her delicate, youthful body. It has nothing in common with earlier pictures which showed figures in heavy clothes that concealed everything. Again we come across a number of priceless artistic delights in this painting, such as some narrow trickles of paint flowing down and furrowing the background. There is no longer any resemblance to El Greco's heavy and dramatic streaks of paint, a style Picasso used to borrow.

So the dividing-line between the two periods is much sharper than might be expected. And it is not only a matter of formal stylistic devices, but also of subjects, which changed considerably. Clowns, tightrope walkers and harlequins took the place of the blind and the decrepit, of beggars, of poverty and depression. Admittedly, though, these people from the world of entertainment always had an air of sadness, and that is how they had always been portrayed by others, such as Antoine Watteau and Paul Cézanne. But they were not always on the dark side of life, they were not born losers. Several times a week Picasso and his friends used to visit them at the Circus Médrano, whose bright pink tent at the foot of the Montmartre shone for miles and was quite close to his studio. This gave him access to a world very much like his own.

With these paintings Picasso touched the hearts of a very sensitive generation. Apollinaire and many others felt a close affinity to these migrants who had no stability or roots anywhere. The famous German poet Rainer Maria Rilke was one of them: when he was living in Munich in 1915, he used to look at Picasso's "Family of Saltimbanques" (p. 25) every day, which belonged to his hostess Herta von Koenig. In his fifth "Duinese Elegy", which he had dedicated to the acrobats, he took

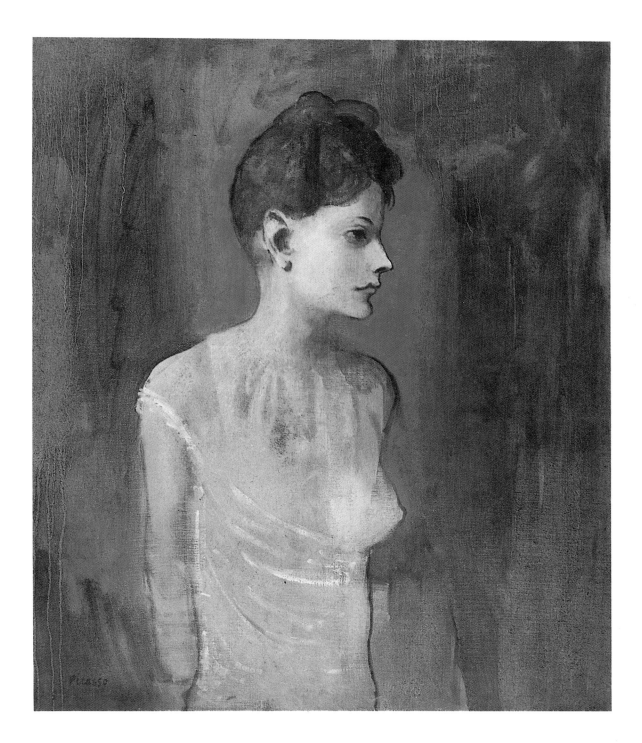

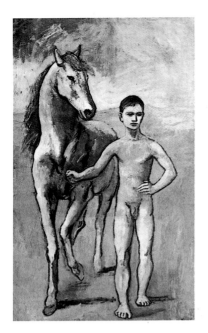

Boy Leading a Horse, 1906
Oil on canvas, 86¾ x 51⅜ in.
Museum of Modern Art, New York

Picasso's painting one step further in his poetry: „But who are they, tell me, these migrants, more ephemeral than we are ourselves (...) coming down from the smooth, well-oiled air, landing on the carpet which has worn thin and ragged from their continuous jumps, this lost carpet of the universe."

With the acrobats Picasso also brought objects back into his pictures: the girl's basket swinging from her hand, the clown's sack thrown over his shoulder, the young man's drum on his back, and the woman's vase in the foreground. Although these props do not actually tell any stories, they nevertheless serve to characterize the figures more accurately. Also, the relationship between the figures is easier and lighter. This can be seen in the easy-going way in which the harlequin is holding the little girl's hand. And yet neither the figures nor the objects lend themselves to reading anecdotes into them. Picasso is describing a condition, not telling a story.

But there is still a noticeably cold atmosphere in this picture, and this is partly due to the discrepancy between the figures's clothes and their surroundings. They are still wearing their circus costumes, but they are not at the circus. They are in an empty and endless expanse of dunes. In this lonely place, without spectators and devoid of any circus atmosphere, the acrobats seem to be strangers. And their costumes have a further function: tight-fitting as they are, they seem like second, brightly coloured skins, thus allowing the painter to emphasize the shapeliness of their bodies. What a difference when compared to the veiled figures of Picasso's previous phase. Picasso's new interest in rendering three-dimensional shapes in his paintings may well have been due to his first endeavours as a sculptor at that time.

In his picture of the acrobats' family Picasso again approaches the classical ideal of beauty. The elongated figures have disappeared, their gestures have lost all pathetic mannerism, and, like all the figures in his pictures from now on, they are standing with their feet conspicuously apart and pointing in different directions. At that time Picasso used to pay frequent visits to the exhibition rooms of the Louvre which contained Greek and Roman sculptures. It was as if he wanted to make a point and show how well he had studied the rules of classical beauty shortly before he declared them invalid with his cubism.

In his painting "Boy Leading a Horse" (p. 24), Picasso demonstrates, as it were, his knowledge of classical beauty. And what could be more suitable for this purpose than a young man? He has, of course, to be naked, because that enables the artist to underline his balanced proportions. Even the relationship between the figure and the surroundings is no longer irritating. Man and nature are in full harmony again. This can also be seen in the choice of colours which links all the elements of the picture to one another without being considerably different from their colours in the real world. Man and animal move forward together, united by their postures and the inclination of their heads. The only thing that is missing as a link between them is the halter. Interestingly, this means that there is not really any motivation for any movement within the picture, for movement would have to be initiated by some kind of action. Instead there is an imaginary link between man

"To me there is no past or future in art. If a work of art cannot always live in the present it must not be considered at all. The art of the Greeks, of the Egyptians, of the great painters who lived in other times, is not an art of the past; perhaps it is more alive today than it ever was. Art does not evolve by itself, the ideas of people change and with them their mode of expression." PICASSO

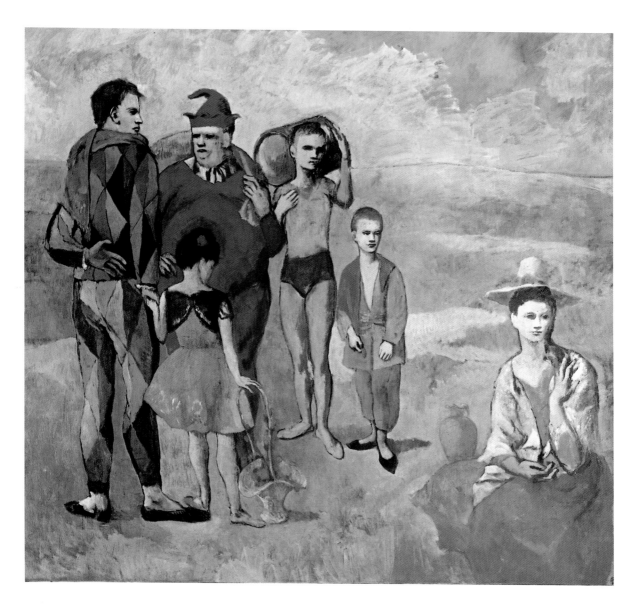

The Family of Saltimbanques, 1905
Oil on canvas, 83 ¾ x 90⅜ in.
National Gallery of Art, Washington

"People say that I seek. I don't. I find."
PICASSO

La Toilette, 1906
Oil on canvas, 59 ½ x 39 in.
Albright Knox Art Gallery, Buffalo (N.Y.)

and nature, caused by the harmony of their movements, their grace and classical proportions. This is reminiscent of a Greek statue whose most fragile parts have broken off and been lost so that only Beauty can be admired.

In 1906 Picasso's frequent visits to the Louvre began to have more and more of an effect on his paintings. "La Toilette" (p. 27) shows Fernande combing her chestnut brown hair. This is a private picture and an intimate one, but it is far from a typical scene in a lady's dressingroom. In those days Fernande was Picasso's goddess of love, the embodiment of feminine beauty, his Venus for everyday use. It seemed obvious to have recourse to ancient Venus statues and to apply their conventional forms to his own goddess of beauty. The result was a statue of flesh and blood that could be admired from afar and at the same time desired passionately. Everything in this picture seems natural: the familiar position of her legs, with her feet pointing in different directions, her arms meeting above her head, her head gracefully inclined towards the mirror, and yet this is nothing but beauty arranged in a classical way. And this is in fact the theme of the picture: not beauty as an end in itself, but its enactment. Fernande is doing her toilet and trying to enhance her abundant attractiveness by means of the right kind of arrangement. She is making use of the mirror so that she can see herself arranging her beauty as portrayed perfectly by Picasso. In this painting he is holding a mirror before her – reverently, like the servant in the picture.

For the time being, his use of classical elements has come to a climax. Picasso has been impressively demonstrating his knowledge of antique sources, he has shown how these traditions could be put into practice. And, as a side-effect, he had also shown that he could easily meet all the demands of technique and expertise. The next step that obviously suggested itself was to question these traditions. But with cubism Picasso did not just shyly express doubt about traditions, he revolutionized painting. Cubism marked the end of a more or less continuous development of Western art.

In cubism there was no room for the unreserved pathos of the Blue Period or the ingratiating aestheticism and melancholy of the Rose Period. It was not until after cubism that Picasso returned to more traditional patterns. But even then he did not use antique sculptures again, but adopted a classicist style.

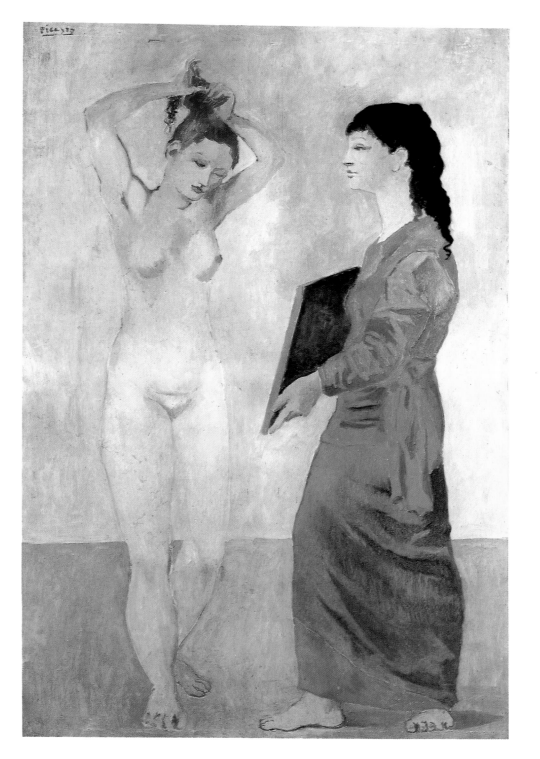

Picasso's Drawings and Graphic Art

Picasso said once that a painting could only ever be imitative, whereas a line drawing could never be. We know this from his long-standing friend and art-dealer Daniel Henry Kahnweiler, to whom he mentioned his ideas about drawings in a conversation in autumn 1933. Picasso believed that drawings were far more important for the artistic rendering of ideas, because they had more immediacy. Another remark of Picasso's sheds even more light on his concept of art: "What the artist does is less important than what he is." One is tempted to continue this quotation, saying that what the artist is can only find expression in utter and complete spontaneousness.

Even when Picasso was a child, his pencil drawings used to be full of precision and accuracy, as well as expressiveness and vigour, like notes in shorthand. When he was only nine years old, he would vigorously draw a line and create the back of a charging bull in an arena. A quick pendulum-like curve was enough to render the parasol of a lady he had been observing. Heads become clusters of little balls, and wild figures of eight represent the less important people in the picture.

In 1894/95 Picasso would still sign his pictures "P. Ruiz", and this is his signature on a study he

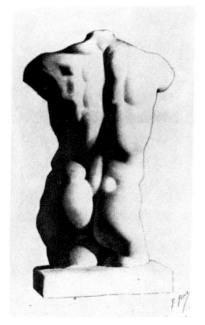

Study of a Torso, after a Plaster Cast, 1894/5
Charcoal, 19 ¼ x 12 ⅜ in.
Musée Picasso, Paris

Pablo Ruiz began to sign his pictures as "Picasso", his mother's name. His drawing of a nude standing man, which would have been worthy of a finally examination project, gained him admission to the academy in Barcelona. In October 1897 he produced another entrance project in practically no time at all and joined the final year of the Royal Academy of Madrid. A month later he wrote to a friend: "I don't want to follow a rigid school, because that would only level the individual differences between its pupils." A month later, in December 1897, Picasso left the academy. The drawings which young Picasso produced between 1895 and 1900 were landscapes, portraits, even menus from his favourite café "Els Quatre Gats", and they already show a marked ability to observe and simplify in a truly masterly way. Picasso was not interested in the forced naturalism of painstakingly accurate little pencil lines, nor in the correct rendering of what he could see with his eyes, but rather in the reflexes that his objects called forth in his own vivid imagination, and this is what he put on paper with his pencil, charcoal, brush or even ink. It seemed as if he did this without any effort at all.

It is in Picasso's sketch books that we are most

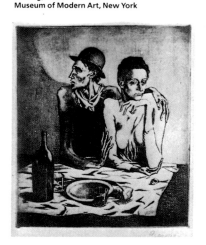

The Frugal Repast, 1904
Etching, 18 ¼ x 14 ¾ in.
Museum of Modern Art, New York

made that year: it shows the perfect modelling of a plaster torso by means of light and shadow. He used charcoal for this piece of work, and to bring out the curves of the muscles he pressed his charcoal so gently into the grainy paper that even the slightly damaged surface of the plaster figure became noticeable as such. This is not an idealised male torso, but quite obviously the plaster cast of a stone figure with the sun shining on it from the side. The sketchy outlines of the pedestal also help to reveal it as such.

It was such academic pieces of work which convinced Picasso's college teachers. And in an academic sense, they are indeed perfect, but they do not leave Picasso much scope as an artist. Another person who was convinced was Picasso's father, that good and honest art teacher Don José Ruiz Blasco, who handed his own palette to his thirteen-year-old son in 1894, with the rather alarming resolution never to paint again. From this point onwards

Standing and Seated Woman, 1906
Charcoal, 24 x 18 ¼ in.
Philadelphia Museum of Art

Standing Female Nude, 1911
Charcoal, 19 x 12 ¼ in.
Metropolitan Museum of Art, New York

**Sculptor and Model by a Window, with
Overturned Sculptured Head, 1933**
Etching, 14 ½ x 11 ¾ in.
Plate 69 in the Suite Vollard

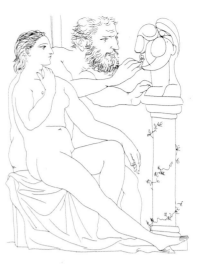

**Seated Model and Sculptor
Studying Sculptured Head, 1933**
Etching, 10 ½ x 7 ⅜ in.
Plate 38 in the Suite Vollard

likely to find clues as to his methods. Again and again, he would take certain motifs and discuss them, as it were, in his drawings, thus arriving at an endless number of new ways of expressing something, with only very slight differences between each drawing. These were not meant to be improvements of an original draft, but a way of constantly and deliberately exploiting a particular theme. Picasso never aimed at a final, conclusive formula for a motif. When we look at the different variations of a theme, they each form independent works of art. In relation to one another, they are like mirror images of the same object, but in the facets of a richly and elaborately cut crystal glass.

Apart from Picasso's drawings, paintings and sculptures, there is of course his graphic art which is a quite independent part of his art in general. It also reveals the hand of an extremely skillful artist. Having been initiated by well-known masters into the technique of gravure printing, he knew as early as 1904, in his second etching called "The Frugal Repast", how to use this medium expressively. With vigorous strokes of the etching needle, sharp contours and dense hatchings within the picture, this last great masterpiece of Picasso's Blue Period takes the dark and sombre atmosphere of his paintings even further and introduces an element of merciless realism. Shortly afterwards, in Paris and also in the Catalonian village of Gosol, when on a summer holiday with his friend Fernande in

1906, Picasso began to paint his magnificent gouaches and water-colours of the Rose Period: subjects from the world of the circus and female nudes, with gently modelled contours instead of whole patches of colour, give these figures a gracefulness that is almost

Face (Marie-Thérèse Walter?), 1928
Lithograph, 8 x 5 ½ in.

classical. Picasso's style seemed to keep changing again and again: his charcoal drawing "Seated and Standing Woman" was made in 1906, while he was making preparations for a large-format oil painting in which he wanted to emphasize the heavy bulkiness of female bodies. Compare this charcoal drawing with another nude picture of 1911, with the same technique, but in the style of analytical cubism, and you can see the immensely wide range of his artistic expertise, his power of imagination and his ability to put it into practice.

Picasso made more than 2000 etchings, using a number of different techniques. Relief printing, however, was not a method he used very frequently, with only very few wood-engraved pictures and no lino-cuts until much later in his life, when he discovered this technique in his old age. Most pictures were made by a process of gravure or planography, with an emphasis on etchings and lithographic pictures. These two techniques offered the least amount of resistance to his original idea of spontaneousness in his drawings and were therefore more suitable for his hurried method of working.

Picasso was for ever searching for new methods and techniques to put his ideas into practice. For example, he often used a mixture of different engraving techniques, such as etching combined with a scraper, or etching and aquatint. He even used one particular technique which had become extremely rare

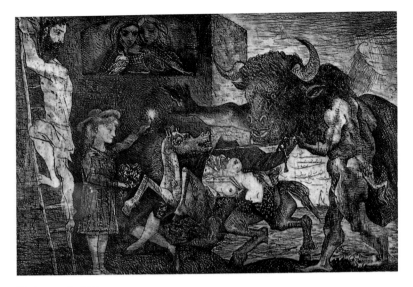

Minotauromachy, 1935
Etching and scraper, 19 ½ x 27 ½ in.
Museum of Modern Art, New York

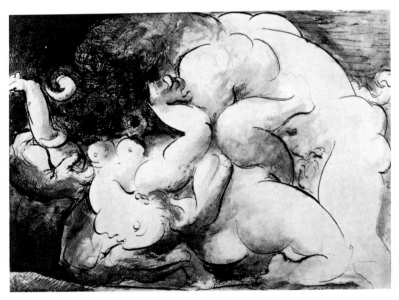

Minotaur and Nude, 1933
India ink on blue paper, 10 ⅝ x 24 ⅜ in.
Art Institute of Chicago

and in which sugar was used: a drawing was made on a plate, with India ink and sugar water, then a layer of asphalt varnish was added, the plate was immersed in water, and the dissolving sugar had the effect of rupturing the varnished layer and lifting it off. The most outstanding example of this technique is his aquatint etching of 1936, called "Faun Unveiling a Woman". About 100 of Picasso's etchings made between 1930 and 1937 have been put together in a magnificent collection of his graphic art, and are exhibited at the "Suite Vollard", named after Picasso's friend and art dealer Ambroise Vollard, who promoted them. One of Picasso's favourite themes was "the sculptor's studio". With 46 pictures, it occupies the largest amount of space. There is a serene, yet almost cheerful atmosphere between the sculptor and his model in this diversity of pictures, with different views of the same topic. They illustrate that happy phase in Picasso's life when he devoted nearly all his time to sculpting, in the peace and quiet of Chateau Boisgeloup. As in his earlier drawings, his contours are nearly always modelled very softly, and even in his etchings this is done in such a masterful way that the curves of the gracefully formed bodies become visible in the contours, without any need for spaces to be filled.

But the Suite Vollard also includes five variations on the theme "The Embrace", in which the meticulousness of classical line drawings has made room for a tremendously expressive dynamism. Both thematically and stylistically they are related to the bold, large-format India-ink drawing "Minotaur and Nude" of 1933, with its almost baroque dynamism and bulkiness of the bodies.

The myth of the Minotaur, that monster with a human body and a bull's head, became more and more important in Picasso's art of the 1930s, and especially in his drawings and his graphic art. Sometimes the monster was triumphantly ferocious and animal-like, sometimes he would take part in a wild banquet in the studio, sometimes he would collapse fatally wounded in the arena, sometimes he was seen clumsily caressing some sleeping beauty. Picasso's "Minotauro-machy" of 1935 is probably his most significant work of graphic art and one of the most important pictures of the twentieth century: it shows the pitiful, helpless, fumbling, blind Minotaur as he is being led through the darkness by a little girl with a candle. In the middle, between the girl and the Minotaur, there is a shying horse, frightened, with dilated nostrils, its body torn open, and its entrails bursting out. On its back there is the body of a fatally wounded female bull-fighter, with a bare breast, while on the left a bearded Christ figure is climbing up a ladder. Antique legends, the world of bull fights and Christian associations have been combined in an allegory which successfully eludes all attempts to find a meaning.

The theme "death of a female bull fighter" had been treated by Picasso in a number of

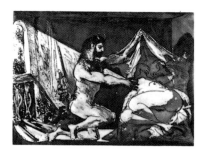

Faun Unveiling a Woman, 1936
Etching and aquatint, 12 ½ x 16 ½ in.
Museum of Modern Art, New York

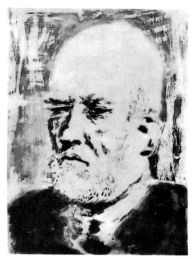

Portrait of Ambroise Vollard, about 1937
Etching on soft surface, 13 ¾ x 9 ¾ in.

Two Catalan Men, about 1933
Etching, 9 ¼ x 11 ⅝ in.
Plate 12 in the Suite Vollard

drawings, etchings and paintings before then. An etching from the year 1934 depicts particularly vividly how a female bull fighter is being raped by the bull. And there is also an India ink painting on wood from the same year that includes a motif which Picasso was to use again in his "Minotauromachy": it shows a bull tearing the entrails out of a wounded horse with his mouth. At the edge of the arena a woman is holding a candle towards the bull. A number of parallels of theme and motif have led people to compare Picasso's etching "Minotauromachy" with his large canvas painting "Guernica" (p. 68 – 9), the picture which Picasso used so impressively to protest against the Franco regime and the brutality of the war. And Picasso did indeed protest against the cruelty of war in a number of pictures. His etching "The Dream and Lie of Franco" (1937) shows in a series of comic-strip-like, fiercely satirical pictures how Franco – depicted as a caricature – is doing his best to destroy justice, humanity and civilization. The last four pictures in the series can be seen within the context of his sketches for "Guernica". In the same year Picasso wrote: "Artists who live and work with spiritual values should not be indifferent towards a conflict which is threatening the highest values of civilization and humanity." One of Picasso's bestknown lithographic works, his "Peace Dove" adorned the poster of the 1949 Peace Congress in Paris (p. 64). For a long time Picasso's graphic art was dominated

by etchings combined with several other techniques. But, having tried his hand at lithography in 1928 – see, for instance, his "Face" – this was the technique that gained more and more prominence from 1945 onwards. That year, he produced about thirty pictures in quick succession, two hundred in the next five years, and by 1962 there were as many as three hundred. He made use of this art so intensively that for nearly three years, i.e. until 1948, he gave up etchings altogether. Just as it is impossible to make a final and conclusive statement about Picasso's drawings, we cannot reduce his lithography to a simple formula either. During his time in the workshop of the Parisian lithographer Mourlot he used to ask for sample prints after each

Paloma Picasso, 1952/3
Ink, 25 ¾ x 19 ⅞ in.

stage, thus enabling us to follow the metamorphosis of these pictures. This method allowed him, in a playful way, to develop an advanced technique of choosing his stylistic devices. Picasso used lithography to cover every single one of this traditional thematic areas, but when he was with Mourlot he was mainly interested in portraits, single figures, still lives and animals. His lithograph "The Bull" of 1945 is a good example of the masterly artistic skill which he developed even with this technique. "The Bull" was printed at eleven different stages, in which they became progressively more abstract until there was nothing more than the contours.
However, Picasso did not stop there. In 1959 he produced his first important lino-cuts, in which he often used up to seven plates printed on top of one another. Later Picasso simplified this process and used one plate which he cut several times, each time with different colours. Nevertheless, with their diversity of form, line and space, Picasso's lino-cuts are masterpieces of twentieth century graphic art.

Bull, 1945
Lithograph, 11 ½ x 16 ⅛ in.
Collection Bernard Picasso, Paris

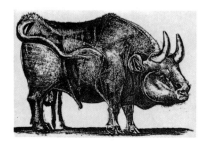

Luncheon on the Grass (after Manet), 1962
Lino-cut, 20 ⅞ x 25 ¼ in.

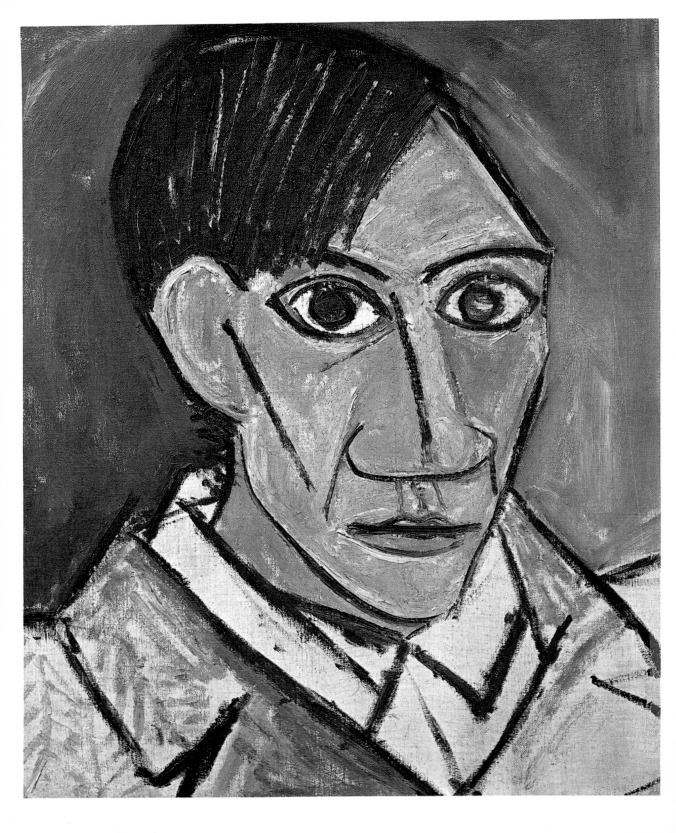

Cubism
1907 – 1917

"Art is a lie". The person who said this was an artist himself: Picasso. But his words were anticipated by the Roman author Pliny, who told the following story about the painter Zeuxis, to prove his skill: Zeuxis had painted some grapes in such a perfect way that the birds would come flying and peck at them. So this was a case where a lie – an invented truth – did its job: fiction and reality had become indistinguishable so that real birds actually wanted to eat painted grapes. Art, then, is indeed a lie – but, conversely, this lie is a difficult art.

Picasso had of course never intended to imitate real life and to deceive people. Before him, it was the impressionists and their successors, who had undermined this century-old dogma, but it was Picasso who achieved the final breakthrough and tore down an outmoded understanding of art. Instead of viewing an object from one central point of view, he began to paint it from more than one perspective at a time. The geometry of a painting was now no longer based on the way we perceive in real life, but made room for an autonomous structure which could only be understood in terms of the picture itself. Instead of true-to-life lighting effects Picasso introduced a distribution of light and darkness that varied from one element in the painting to another.

The differences between Picasso's Rose Period and cubism are enormous. They show particularly clearly not only that there was a turning point in his art, but also that he initiated a revolt against Western art in general. It is a new perception of reality, a new method of inventing truth that enabled him to break the old laws. And this revolt was brought about by a change in Picasso's understanding of himself, as can be seen in the difference between two self-portraits.

His "Self-portrait with a Palette" (p. 2) was painted in autumn 1906. The beginning of cubism was imminent, but there is hardly any sign of it in his picture yet. The way in which Picasso holds the palette with his thumb shows which phase of his art he is still committed to. It is both a thumb and a blob of paint, it is part of the painter and part of the painting, it is pink. Only his face has already acquired a mask-like appearance, the shadows under his chin and on his cheek stop abruptly. The use of lines is gaining importance for the arrangement of the picture, and this is what heralds his next period.

In his self-portrait of spring 1907 (p. 32), painted shortly afterwards, lines have become the dominating structural device. Facial features are

The Reservoir, Horta de Ebro, 1909
Oil on canvas, 23 ¾ x 19 ¾ in.
Private collection, New York

"Braque always used to say that the only thing which really mattered in painting was the intention. And that is true. What matters is what you do. That is the most important thing. And what was particularly important about cubism was what you wanted to do, your intention. And you cannot paint that." PICASSO

Self-Portrait, 1907
Oil on canvas, 19 ⅝ x 18 ⅛ in.
National Gallery, Prague

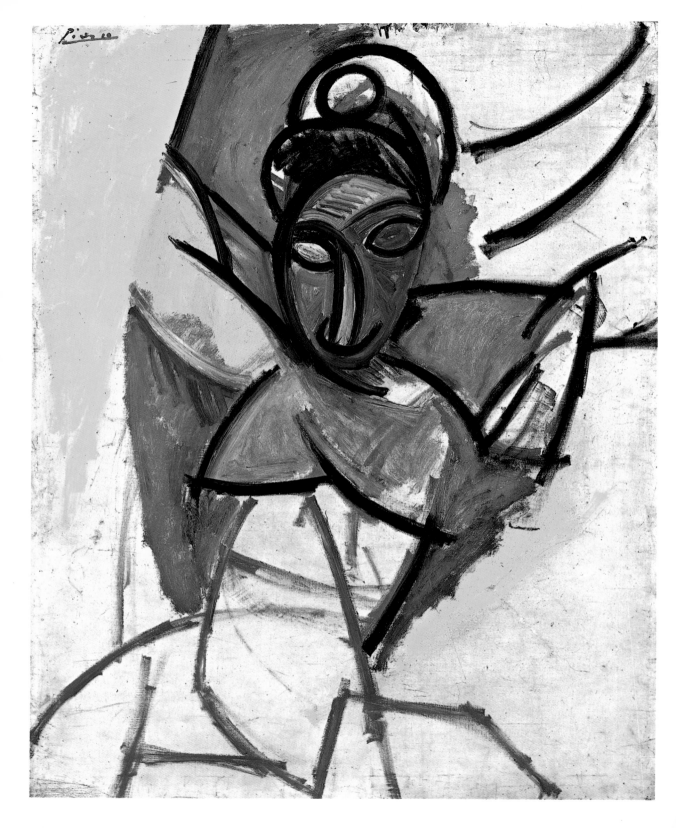

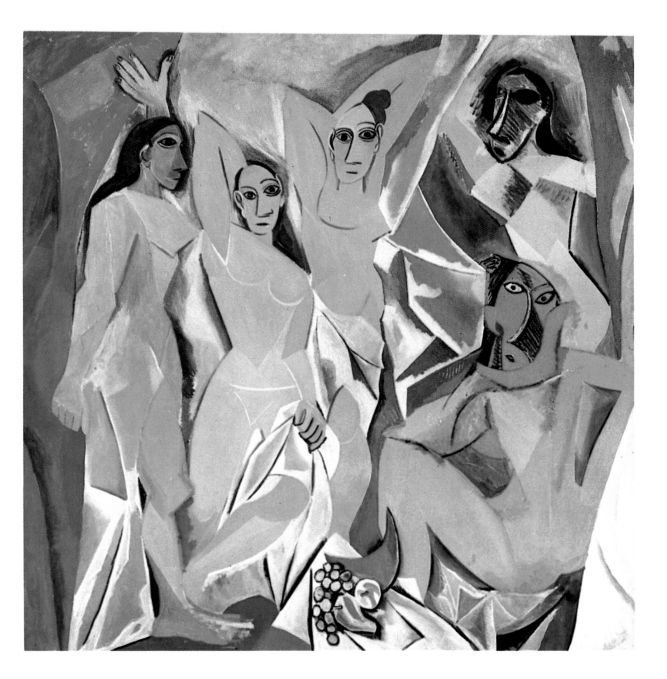

marked by broad, fast strokes of the brush, which also delineate the other areas in the picture. Nearly all areas have been filled with colour, and only very little shaping has taken place within these areas. And in several places the canvas has in fact been left unpainted. At the same time Picasso was experimenting with sketches to prepare his picture "Les Demoiselles d'Avignon" (above). It was not only his method of painting that had changed, but also Picasso's view of himself. There were only a

Top:
Les Demoiselles d'Avignon, 1907
Oil on canvas, 96 x 92 in.
Museum of Modern Art, New York

Left:
Woman (Study for "Les Demoiselles d'Avignon"), 1907
Oil on canvas, 46 ½ x 36 ⅝ in.
Beyeler Collection, Basle

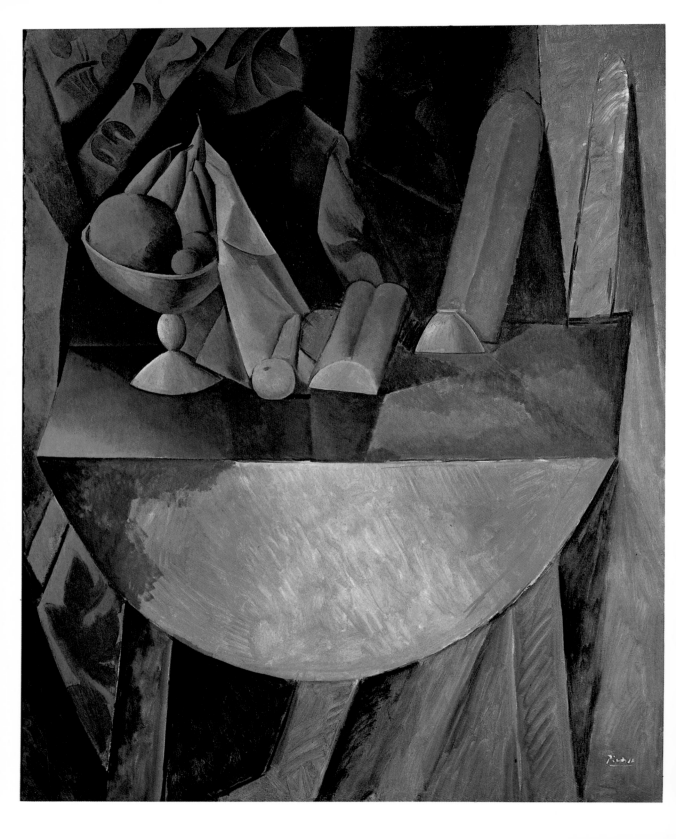

few months between the two self-portraits, but the one shows a youthful Picasso, the other a mature one.

In a sketch (p. 34) for his "Demoiselles" he left the lower half of the picture unfinished. This shows how Picasso used to work: he would start by delineating the contours with a hurried stroke of the brush, and only then fill the resulting areas with bold colours. Finally he would trace the angular lines in black. After each stroke he would pause and take his brush off. Body and head were divided up into angular chunks. Interestingly, the naked woman with her arms folded behind her head was borrowed from a painting called "The Turkish Bath" by Auguste Dominique Ingres who had intended to pay tribute to the well-proportioned shapeliness and the gentle contours of the female body.

Eventually Picasso carried the object of this sketch over into the final version of his "Demoiselles d'Avignon" (p. 35) and placed her right in the centre. There could hardly be more contrast between this painting and Ingres' Turkish bath, steaming hot with erotic sensuality. Her provocative pose has been turned into the exact opposite: her arms are ungainly, her elbows sharp and her head looks like a wedge of flesh. And yet she and the woman on her left are beauties compared with the other female figures.

Their warmly monochrome bodies are reminiscent of Picasso's Rose Period, whereas the other women, with their deformed heads and bodies, look as if they had been knocked about with an axe. If we look at the woman on the right in the foreground, it is impossible to work out exactly how she is leaning on her arms. Her body and head are formed completely differently, both her back and her face are visible at the same time, her eyes and the area round her mouth contradict all laws of nature. Behind her, opening the blue curtain, another woman is entering into the room. Her ugly, misshapen head looks like that of a dog, her face has been divided up by means of red and green parallel lines, her body chopped up into mutually incompatible particles. Finally, the fifth woman in the left-hand corner is completely motionless, and her face has acquired a stony, mask-like quality.

Each individual figure is composed of completely diverse elements. And compared to one another, the figures also obey mutually contradictory principles. On the other hand, they are united by a general geometrical principle which superimposes its own laws on to the natural proportions, and they merge almost completely with the background, which is full of similar rugged cleavages. There are no distinctions of light and darkness that might lend shape to the women's bodies, and together with the combination of several perspectives, this contributes to a general impression of disorientation in space.

Picasso wanted to destroy absolutely everything. His rebellion against the myth of feminine beauty was relatively insignificant compared with his other rebellion: with this picture he wanted to destroy the image that people had been forming of him as a painter, and he was rebelling against the whole of Western art since the early Renaissance. Nevertheless, his painting had not been created out of nothing. Picasso had been studying Iberian and African sculptures. They contained precisely those archaic forms which inspired him to create stylized natural

Bread and Fruit Dish on a Table, 1909
Oil on canvas, 64 ½ x 52 ⅛ in.
Kunstmuseum, Basle

"In the **Demoiselles d'Avignon** I painted a profile nose into a frontal view of a face. I just had to depict it sideways so that I could give it a name, so that I could call it 'nose'. And so they started talking about Negro art. Have you ever seen a single African sculpture – just one – where a face mask has a profile nose in it?" PICASSO

Illustration p. 38:
Portrait of Ambroise Vollard, 1910
Oil on canvas, 36 ¼ x 25 ⅝ in.
Pushkin Museum, Moscow

Illustration p. 39:
Woman with Pears (Fernande), 1909
Oil on canvas, 36 ¼ x 28 ¼ in.
Private collection

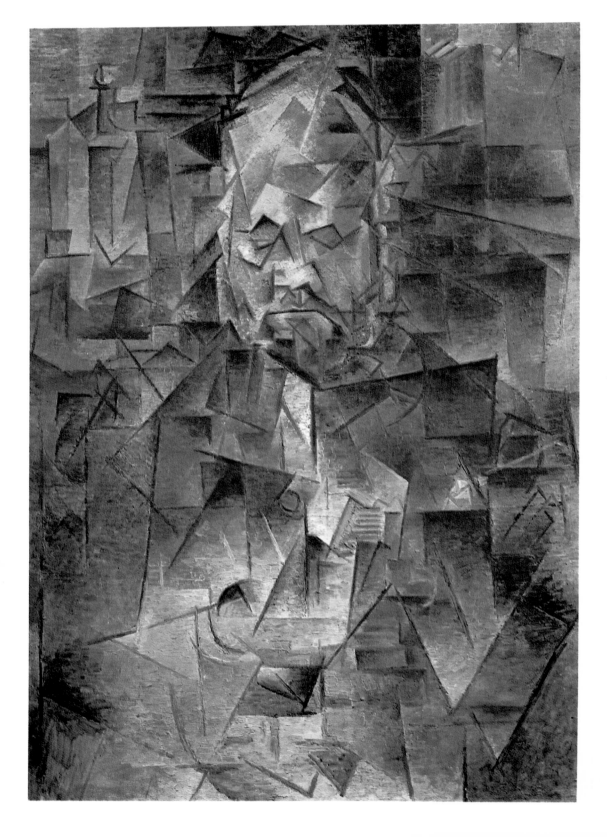

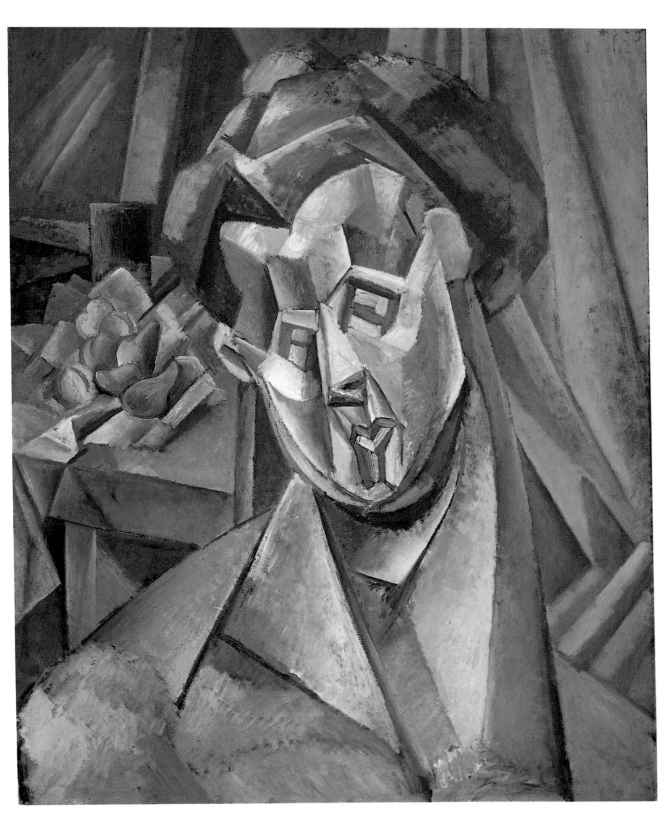

Head, 1909
Ink, 25 x 18½ in.
Private collection, Paris

"When I paint a bowl, I want to show you that it is round, of course. But the general rhythm of the picture, its composition framework, may compel me to show the round shape as a square. When you come to think of it, I am probably a painter without style. 'Style' is often something that ties the artist down and makes him look at things in one particular way, the same technique, the same formulas, year after year, sometimes for a whole lifetime. You recognize him immediately, but he is always in the same suit, or a suit of the same cut. There are, of course, great painters who have a certain style. However, I always thrash about rather wildly. I am a bit of a tramp. You can see me at this moment, but I have already changed, I am already somewhere else. I can never be tied down, and that is why I have no style." PICASSO

"I have often used pieces of newspaper in my collages, but not to produce a newspaper." PICASSO

Guitar, 1913
Charcoal, pencil, ink and pasted paper,
26⅛ x 19½ in.
Museum of Modern Art, New York

forms, then arrange them in rigorous geometrical patterns and finally radically deform them.

Even before Picasso, other artists had shown some interest in „primitive" art, but they never used it with the same frankness and lack of constraint. When Henri Matisse and André Derain were showing their nude paintings at the "Salon des Indépendants", they made the young Spaniard feel ambitious. But they both reacted to his painting with unreserved horror. Even Apollinaire, who had become one of Picasso's admirers, and Georges Braque, whom Picasso had only known for a short time, rejected the painting at first because they just did not understand it. They thought that he had been overcome by some "dreadful loneliness" and were even afraid that, like Derain, he would end up hanging himself in his own studio. But the criticism of his colleagues soon died down, and they began to assimilate his new principles in their own art. Cubism had been born.

Picasso was gradually joined by others. Braque in particular began to contend with him in the development of this new art. But in spite of their artistic rivalry the two painters became friends. For several years to come they were to explore together the possibilities of cubism. In the summer of 1908 they started by going on a holiday in the country together, only to find afterwards that they had painted similar pictures independently of each other.

Picasso's painting "Bread and Fruit Dish on a Table" (p. 36) still follows very closely the principles of this early, monumental cubist phase. The objects of the still life are scattered thinly in the limited space between the edge of the table and the green curtain. The cut edge of the bread corresponds to the semi-circle of the table, there is a bowl of fruit and a cup upside down, and several pieces of fruit. All of these objects are everyday things, but they have one important element in common: natural as they are, they obey certain geometrical principles. On the one hand, this allows Picasso to satisfy Cézanne's demand for simplified forms such as circles, ovals and squares. On the other hand, it gives him an opportunity to demonstrate his new concept of space and to do so in a didactic way by means of lemons and pears. The organisation of space within the picture is no longer uniformly a matter of one central perspective, but each object is looked at from a different angle. This means, for example, that we can look at the bowl of fruit from above without also looking at the bottom of the cup.

In spring 1909 Picasso returned to Horta de Ebro, a secluded spot where, in his student days, he had once withdrawn from the world to consider his future. This was to be one of the most productive phases in his life. His portrait of Fernande, "Woman with Pears" (p. 39) was painted here, marking a further stage in the development of analytic cubism. This was the time when his study of primitive sculpture began to bear fruit. Picasso had never taken any interest in their ethnological content, but had examined their formal principles very closely and had come to the conclusion that they all consisted of a number of clear shapes added together side by side and that this was their common denominator. Accordingly, eye sockets, nose, cheeks, lips etc. had to be looked upon as convex elements which divide the face into distinct sections. Using the

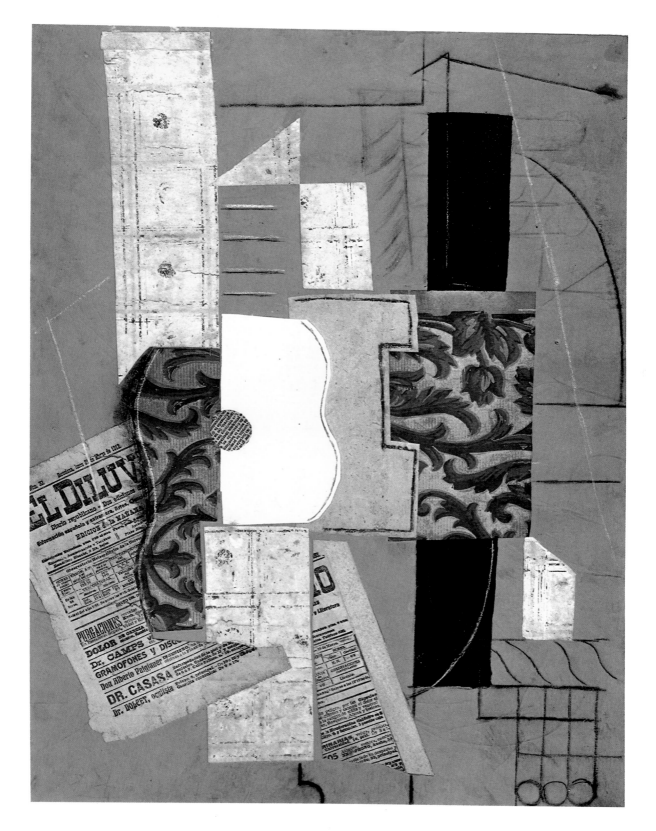

idea of several different perspectives within a picture, Picasso now no longer painted several objects from different angles but one object at a time.

This geometrical method was first applied to simple objects such as cups and brought out their most typical forms, thus making it easy for us to identify objects. Applied to people, however, it tends to have the opposite effect. There are two mutually exclusive approaches: one cannot demand that the individual features of a person should be recognizable while at the same time aiming at a radical simplification of forms in geometrical patterns. Nevertheless Picasso succeeded in maintaining the balance between two main ideas in his art, i.e. naturalism and abstraction, taking reality as the starting point but endeavouring to be autonomous as an artist. Neither of these two principles ever occurred without the other. Picasso did not paint exclusively natural pictures, nor completely abstract ones. But he had now reached a turning point within his cubist phase. Whereas until now the emphasis had still been on the natural side, he suddenly began to paint predominantly abstract pictures.

Picasso's portrait of his art dealer Ambroise Vollard (p. 38) deals with

Pipe, Bottle of Bass, Die, 1914
Pasted paper and charcoal on paper,
9 ½ x 12 ⅝ in.
Private collection

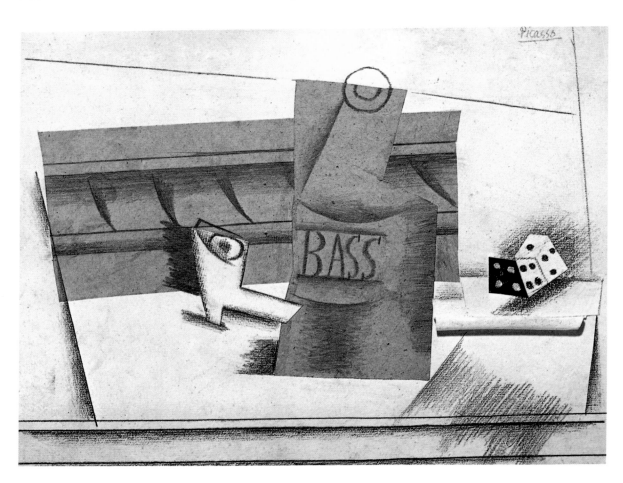

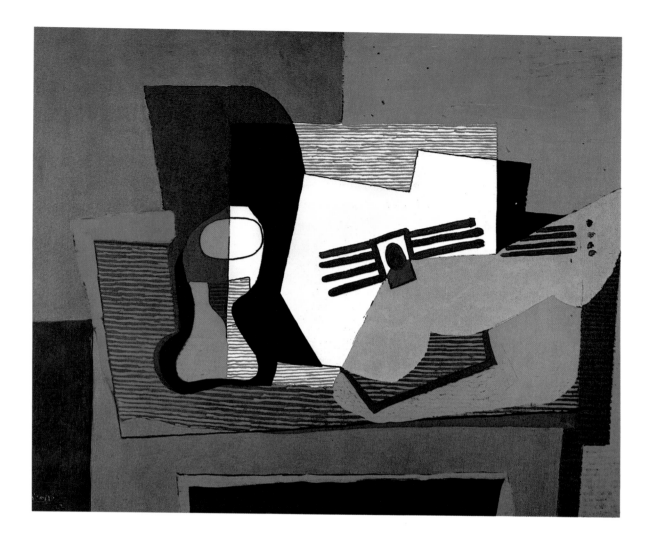

the subject in some kind of geometrical shorthand and therefore tells us very little about the actual person. The contours are obscured by geometrical forms which completely dominate the few remaining fragments of realism. The lines are ambiguous. They are part of an autonomous pattern, but can also be interpreted as a lapel or a handkerchief in the man's breast pocket or an arm. The space within the picture has lost its obtrusively convex areas and has become almost completely flat, no large chunks are placed side by side, and the transitions between the small areas have become smoother. The whole picture is covered by a pattern of prismatic particles.

In the following years Picasso depicted objects in an increasingly disjointed way. He concentrated above all on things he found in his studio, things which already had definite geometrical forms and which were familiar to the observer. Thus each object was still recognisable, even if its proportions were distorted and its general shape disjointed.

Still Life with Guitar, 1922
Oil on canvas, 32 ⅝ x 40 ⅜ in
Galerie Rosengart, Lucerne

"I don't say everything, but I paint everything." PICASSO

Harlequin, Playing Guitar, 1916
Pencil or charcoal, 12 ¼ x 9 in.

"Cubism has remained within the limits and limitations of painting, never pretending to go beyond. Drawing, design and colour are understood and practised in cubism in the spirit and manner that are understood and practised in other schools. Our subjects might be different, because we have introduced into painting objects and forms that used to be ignored. We look at our surroundings with open eyes, and also open minds.
We give each form and colour its own significance, as far as we can see it; in our subjects, we keep the joy of discovery, the pleasure of the unexpected; our subject itself must be a source of interest. But why tell you what we are doing when everybody can see it if they want to?"

PICASSO

Harlequin, 1915
Oil on canvas, 72 ¼ x 41 ⅜ in.
Museum of Modern Art, New York

From the use of individual fragments it was only a short step to the "papier collé" or collage. In his picture "Guitar" (p. 41) he has used pieces of wallpaper, newspaper and coloured paper as ready-made components stuck to the canvas and then painted over with charcoal, pencil and water-colour. This means that the object is not only split up into different fragments, but it is also depicted by means of fragments from the real world. It results in two competing principles within the same picture: the printed piece of paper points to a real newspaper while at the same time forming the sound hole of the guitar. The object is characterized by means of a few typical features. The bulky resonator and the neck with its strings and frets are crude, but sufficiently realistic to prevent the painting from becoming completely abstract.

In his collage, "Pipe, Bottle of Bass, Die" (p. 42) there is a die in the right-hand corner which is unusual. Where we would have expected a simple cube, with no more than three sides visible at a time, Picasso has added a fourth side, painted it black and put it beside the die, as if trying to point to the hidden sides at the back. But not only that, normally the sum of the dots on two opposite sides is seven. Picasso, however, shows the three and the four adjacent to one another. Front and back are both visible. This cubist caprice contains the painter's final word in the argument between the sculptor and the painter, in which the sculptor has been claiming superiority on the basis that he is able to depict an object from all sides.

His "Still Life with Guitar" (p. 43) of 1922 belongs to a later phase but recalls Picasso's earlier collage technique, this time by means of painting only, thus seeming like a belated final chord of cubism.

However, synthetic cubism did not reach its climax in collages with their scraps of real life stuck together, but in Picasso's use of paint and brush, in the way he would put together a number of coloured areas like pieces of paper which had been cut out. In his "Harlequin" (1915, p. 45), a favourite topic from earlier phases, there are coloured fragments that float about disjointedly on the black background that surrounds it. Picasso has even carefully avoided mooring the harlequin to the edge of the picture. The reason why the clown can be identified as such is not that there is a vestige of naturalism which defies abstract form, but rather that the diamond-shaped pattern of his garment – which is his hallmark – is itself abstract in real life.

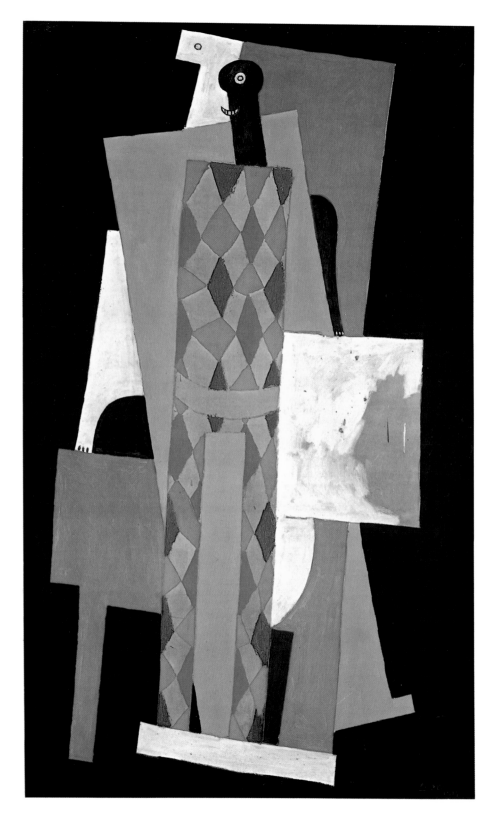

Picasso's Sculptures

There was no time at which Picasso's sculptures could be regarded as following any one particular style or be narrowly defined. As in his paintings and drawings, he always used to reserve for himself the freedom to be capricious or even eccentric, or to be totally unproductive during certain periods of his life. Nevertheless, it is true that his interest did keep shifting towards different questions and problems in the art world, which demanded each time that he should try out different styles and techniques.

When Picasso was young, he saw his vocation exclusively in painting and drawing pictures. His first known sculpture goes back to the year 1902. It is a seated woman, akin in surface and

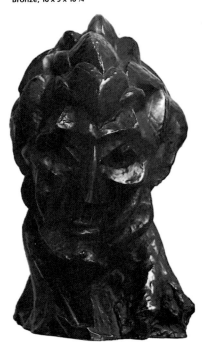

Head of a Woman (Fernande)
Bronze, 16 x 9 x 10¼

structure to Rodin's great sculptures, and clearly expressing that profound sadness which he felt during his Blue Period. Like his other early sculptures, it came to us by mere chance: as was often the case, Picasso found himself in financial difficulties, and so he sold all his old clay models to the art dealer Vollard who had them cast in bronze. The sculptures which Picasso produced in 1906/07 mainly consisted of roughly hewn and coarsely simplified female figures, which reflected his interest in African sculptures – an interest which had found even stronger expression in his paintings, so that some people even speak of a "Negro" period in his art. This was the time when Picasso was beginning to build up a sizeable collection of African sculptures and to fill his studio with them. His subsequent phase of analytical cubism found its expression very early in his famous "Head of a Woman (Fernande)" (bottom left) of 1909. It is interesting to compare her with his "Woman with Pears" of the same year, another portrait of his mistress Fernande Olivier. The sculpture shows the difficulties that Picasso had to contend with: cubism had really been developed for twodimensional pictures, and it was rather difficult to transfer this new idea to the three dimensions of a sculpture. Although he succeeded in applying analytical cubist principles to the facet-like structure of the surface, he did not do the same for the shape of the head. The inner structure of the head did not lend itself to such an analysis into segments. However, this sculpture provided some quite important inspiration for other sculptors at the time. His own cubist interest, though, shifted back to painting, drawing and graphic art, at least for the time being.

It was not until Picasso discovered the technique of collage, or "papier collé", that he started thinking about sculptures again. Sticking paper onto a picture is, in a way, already a step beyond the strict twodimensional character of the painting. And when he began to use other materials, such as cardboard, tin, wood, string and wire, his pictures changed more and more into reliefs. This was a logical consequence, and it was all the more apparent in the way in which some parts of his pictures could be folded out from the surface. The beginning of this development was marked by Picasso's "Constructions", a whole series of musical instruments which had been put together with cardboard, tin, wire, painted wood and painted or corrugated metal. His "Violin" of 1915 (top right) is a good

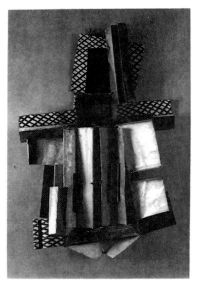

Violin, 1915
Construction of painted metal and wire,
39⅜ x 25 x 7 in.
Musée Picasso, Paris

example. The development towards three dimensions as well as the breaking up of structures happened in several stages, until there were completely free-standing objects, such as his "Violin and Bottle on a Table" of 1915/16, a construction that consisted of colourfully painted pieces of wood, nails and string. With this new idea Picasso initiated a number of revolutionary innovations in twentieth century sculpture. The traditional method had been either additive or substractive until then: a figure was either built up, out of clay, or it was hewn out of a block of wood or stone. Now, however, it was a matter of using a number of simple, ready-made components and fitting them together into varied and complex structures. This was indeed the beginning of new chapter in the history of sculpture, a chapter that can be aptly called "constructivism".

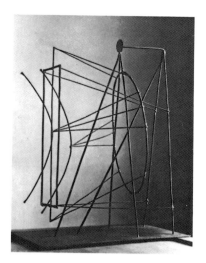

Wire Construction (offered as a maquette for a monument to Guillaume Apollinaire), 1928
Metal wire, 19 ⅞ x 16 x 7 ¼ in.

sculptor is asked what kind of monument he had in mind and which material he would like to use, he answers: "I want to make him a statue out of nothing, like poetry and fame". And Picasso himself expressed his enthusiasm for such a "monument out of nothing, out of emptiness". But although this monument would have expressed the poet's spirit more accurately than a thousand eloquent words, it was rejected by the relevant committee as being "too radical". Nevertheless, Picasso's spacious, transparent constructions provided yet another significant impulse in the history of sculpture, an impulse which bore fruit with some of the greatest artists in this field. During the next three years Picasso produced a large number of "transparent" figures welded together with all kinds of pieces of metal. But as soon as he had acquired Chateau Boisgeloup, he began to use clay and plaster again. This was the time when he made his magnificent drawings and etchings on the theme "The Sculptor's Studio". But unlike Picasso's drawings, his sculptures at this time were devoid of any classical grace. Instead,

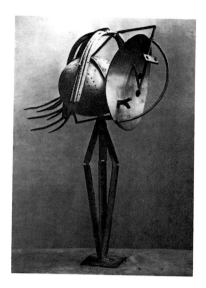

Head of a Woman, 1931
Bronze (using painted iron, sheet metal, springs, and two colanders),
39 ⅜ x 14 ½ x 23 ¼ in.

Head of a Woman, 1932
Bronze, 33 ⅞ x 12 ⅝ x 19 in.
Musée Picasso, Paris

Picasso's musical instruments, first as relief paintings and then as free-standing constructions, formed the climax of his analytical cubism within the sculptural arts. Around 1916 Picasso turned almost entirely towards the graphic arts for the next ten years and produced hardly any sculptures at all. Then in 1928, after a series of watercolour sketches, he eventually produced his famous wire constructions. Picasso submitted them as models for a monument in honour of the poet and critic Guillaume Apollinaire who had died in 1918 and who had been a good friend of his. His final version, his "Wire Construction" of 1928 (top left), reached the monumental height of over twelve feet. This sculpture, which is now in the Museum of Modern Art in New York, was regarded as final even by Picasso himself. A close look at it reveals that it is by no means a purely abstract construction consisting simply of a few iron poles welded together, but rather the spatial representation of a line drawing of a woman on a swing. The small, round metal plate has to be seen as the head and the oval shape underneath as her body. Her arms are protruding from it and pulling at the ropes of the swing, while her feet are pushing against the lower part of the swing. The wide swinging movement has been captured hovering between ascent and descent. It is as if time had stood still. This three-dimensional drawing suspended in time, without mass or bulk, can be understood more easily if we look at its history and its origins in Apollinaire's works. In his poem "Le poète assassiné" (The Assassinated Poet) there is a rather startling description of a monument for the dead poet Croniamantal. When the

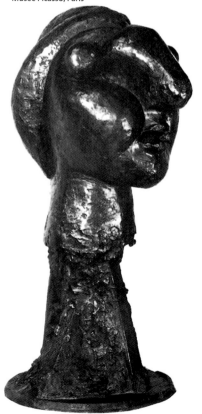

they are reminiscent of stone age figures, with their crude simplified forms – forms which had already been part of some of his painting for a while and were to play an important role in Picasso's art until they reached their climax in "Guernica" (p. 68 – 9).

His sculptor's studio at Boisgeloup saw the creation of female bodies out of bulgy, dough-like lumps stuck loosely together, with gigantic heads that consisted of overlapping globular shapes, were joined to elongated necks and had bulgy protuberances as their noses. His strangely deformed "Head of a Woman" (1932) (bottom right) is part of a series of four heads, which started with a portrait of his mistress Marie-Thérèse Walter – a portrait that was full of almost classical grace. The last stage of this series was a complete reduction of all grace, a grotesque clenching of human form into no more than a lumpy mass. But this is only a description of their formal features. The enormous wealth of emotion that is behind these intimate protraits cannot be grasped with a verbal description, but is only accessible to an unprejudiced onlooker via his own emotions. Again, after an extremely intense phase of sculpting, Picasso ceased altogether for a longer period, until eventually, in 1943, he began to produce a number of constructions out of pieces of metal which he had found by chance. Two famous examples of these rather ingenious sculptures are his "Blossoming Watering Can" and "Head of a Bull" (top middle, p. 48).

This is how Picasso describes how he assembled the various pieces for his

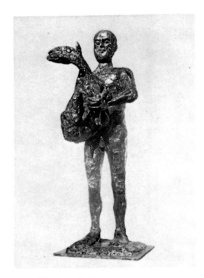

Man with Sheep, 1944
Bronze, 86 ⅝ x 30 ¾ x 28 ⅜ in.

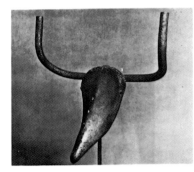

Head of a Bull, 1943
Bronze (after assemblage of bicycle saddle and handlebar), 13 ⅛ x 17 ⅛ x 7 ½ in.

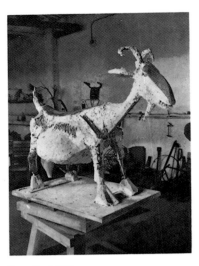

Nanny-Goat, 1950
The sculpture shortly before its completion in the studio at Vallauris. (Palm leaf, ceramic flowerpots, wicker basket, metal elements, plaster) 47 ½ x 28 ⅜ x 55 ⅛ in.

construction: "One day I found an old bicycle saddle in a heap of scrap metal, and right next to it there was a rusty old handlebar ... I immediately joined the two parts in my mind ... The idea just came into my head by itself ... All I had to do was weld the two pieces together. The wonderful thing about bronze statues ist that they give so much unity to the most diverse objects that it gets quite difficult to tell the different elements apart. But there is also a danger in that: if it gets to the point where you can only see the bull's head and not the saddle and the handlebars, which it consists of, then the sculpture becomes totally uninteresting."

At the same time as these amazing constructions Picasso also used quite a different technique and after a long period of preparation, with a large number of drawings, he finally produced one of his most famous works, a clay sculpture called "Man with Sheep" (top left) (1944). Picasso himself used to tell the story of how he came to finish the sculpture: it was over six foot high, and after he had spent only two consecutive afternoons on it, he discovered that he had not prepared it properly. Then for two whole months, he did not even touch the metal frame of the sculpture. But one day he decided quite spontaneously to have a large quantity of clay brought to his studio, and so he began to work on it. After a while, however, he suddenly realized that the sculpture would never hold together. "The figure began to shake under the weight of the clay. It was terrible! It was going to collapse any moment. Something had to happen quickly ... So we tied the man and his sheep to one of the rafters under the ceiling with some string, and I decided to cast him in plaster immediately. The same afternoon.

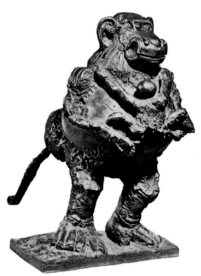

Baboon with young, 1951
Bronze (after an original of plaster, metal, ceramics and two toy cars, 21 ½ x 13 ½ x 21 in.

Goodness, what a job! I don't think I'll ever forget it ... I was really going to do a bit more work on it ... Can you see his long, spindly legs, his feet which are only hinted at and not really worked out at all? I'd have loved to model them like the rest of the body, but there just wasn't any time."

Again, this is typical of the way Picasso used to work: he would never puzzle out rationally how to achieve grand effects, but follow his feelings and intuitions and then make a spontaneous decision and get on with it quickly. That is what makes Picasso a great artist, and his greatness is not diminished by the fact that he never got round to finishing the feet of his "Man with Sheep". On the contrary! When life became really unbearable during the German occupation of Paris and many of his friends had to hide from the Gestapo, then this monumental figure became a powerful reminder to everyone that Picasso still had hope and that he still believed in humanity, a reminder which everyone understood.

Even in his later years Picasso continued to assemble ready-made objects which he had found somewhere, thus creating sculptures in a way that never ceased to be both playful and ingenious. When he started his larger-than-life "Woman with Baby Carriage" in 1950 (bottom right), he used a wide variety of different pieces of metal, such as bits from a real pram, but also cake pans and a stove plate, modelled in clay, which he then stuck together and created a most fascinating sculpture.

When Picasso created this statue of a human figure, he never left any doubt as to the fragmentary nature of the elements that formed part of the sculpture, and it is indeed

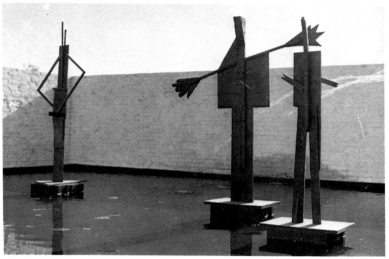

The Bathers, 1956
The illustration shows three of the six sculptures at
the Documenta II exhibition in Kassel in 1959.
Bronze (after carved wood). From left to right:
The Man at the Well
(89 ¾ x 34 ⅝ x 38 ⅜ in),
Woman with her Arms Stretched Out
(78 x 68 ½ x 20 ½ in),
The Young Man
(69 ¼ x 25 ⅝ x 18 ⅛ in).

quite obvious what exactly it consists of. But
with his famous "She-Goat" of 1950 (p. 48) he
went quite a different way. This is how his
current mistress Françoise Gilot put it: "First
Picasso had the idea that he wanted to make a
sculpture of a goat. And only then did he
actually start looking for objects which he
could make use of ... Every day he used to go to
the scrap metal yard, and before he even got
there he would rummage in all the dustbins
which we passed on our way to the studio. I
used to walk beside him, pushing an old pram,
and he would throw in all the junk that he
thought might come in useful."
And so the goat consists entirely of objects he
had found, a wicker basket, palm leaves, bits of
metal tube, flower pots, pieces of china, etc.,
but these are no longer recognizable as such,
but have been stuck together cleverly with
plaster, thus achieving quite an accurate image
of a goat. His "Monkey and Her Baby" (p. 48),
was created in a similar way: the head of the
baboon consists of two toy cars from his son
Claude, stuck together bottom to bottom.
In his late sculptures Picasso went back to using
planes and colourfully painted surfaces. But in
1953, while he was still making the
constructions mentioned above, he began to
produce sculptures from old wooden boards,
which he would work on and then nail
together, such as his group of "Bathers" (top
left cast in bronze in 1956). These figures are
larger than life, thus showing another
interesting feature of his late works: in the
1960s some of his metal and paper figures,
which were cut, bent or corrugated and
painted in glowing colours, were reproduced
in steel or concrete and reached heights of over
sixty feet.

Woman with Baby Carriage, 1950
Bronze (after assemblage of cake pans, terra-cotta,
stove plate and push-chair),
79 ⅞ x 57 x 26 ⅝ in.

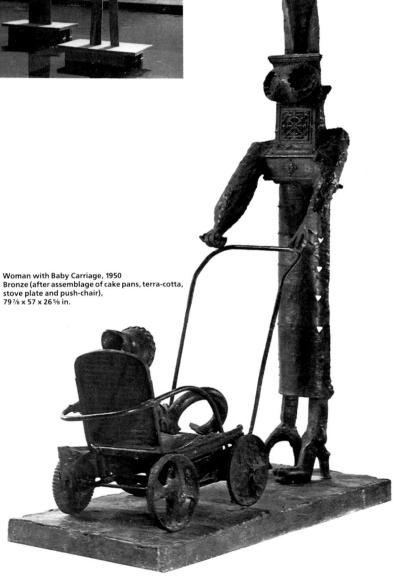

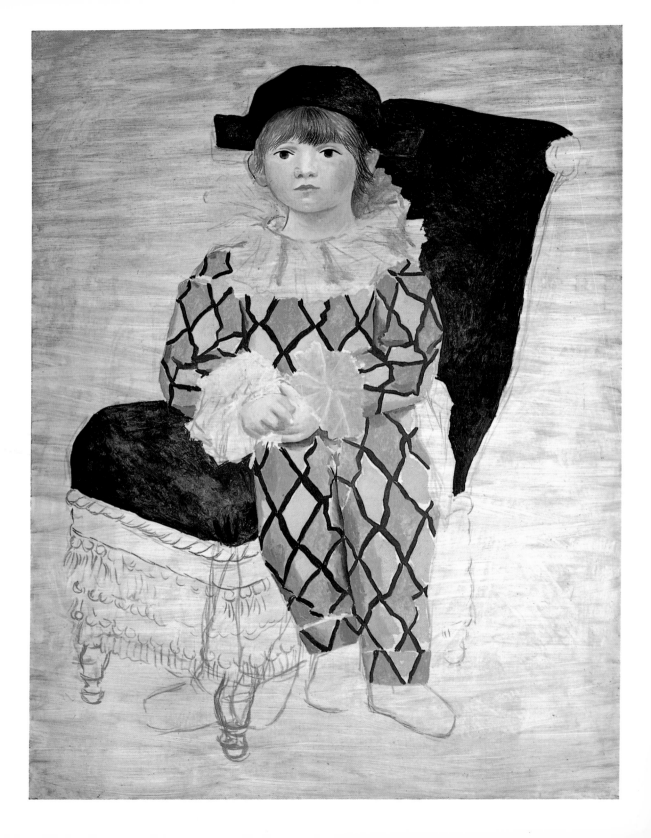

The Twenties and Thirties
1918 – 1936

"The poems I am writing at the moment will be much closer to your present way of thinking. I am trying to renew poetic style, but within a classical framework. On the other hand, I don't want to lapse into imitating others." These words, which were written to Picasso by Guillaume Apollinaire in 1918, prove that it was not just a matter of personal taste when the painter turned towards the cool, concrete language of formal classicism. The poet Apollinaire, who had been his old friend since cubism, was going through a similar change: a renewal within art and an orientation towards the classical tradition no longer had to be understood as opposites.

It was a trip around Italy from February to May 1917 that caused Picasso to distance himself from the analytical, almost dissecting way of looking at things that was inherent in cubism. This was the time when "Parade", a ballet by the young poet Jean Cocteau and the composer Erik Satie, was going to be rehearsed in Rome. Picasso had designed the backdrop for it. The X-ray vision with which he used to penetrate the surface of life was temporarily dimmed by the unrestrained cheerfulness in the Italian capital, the highspirited exuberance of Sergei Diaghilev's Russian ballet company, and his friendship with the dancer Olga Koklova. He began to appreciate anew the joy of observing daily life, the movement of people walking by, and normal everyday relationships; he began to gain confidence in the simple perception of the commonplace, and, above all, he expressed this sudden change in his art.

Picasso's "Sleeping Peasants", (p. 52), painted in Paris in 1919, is still a reflection of his time in Rome, where, on the Spanish Steps, there used to be dozens of youngsters in picturesque clothes who were simply waiting to serve as models or subjects for tourists, painters or photographers. Following strictly the laws of the genre, Picasso paid homage in this picture to the serene joy of simple things. He painted the intimate relationship of a couple with hardly any problems. The simplicity of their joy is reflected in the woman's indulgently submissive posture and the peasant's protective gesture as he is leaning over her. In spite of, or perhaps because of, their everyday appearance they seem monumental and look like sculptures. And this impression is hardly diminished by a number of cubist relics, such as the woman's hands which are strikingly different in size.

"I cannot bear people who talk about Beauty. What is Beauty? In painting you have to talk about problems! Paintings are nothing but research and experiment. I never paint a picture as a work of art. Everything is research. I keep researching, and in this constant enquiry there is a logical devlopment. That is why I number and date all my paintings. Maybe one day someone will be thankful for it.
Painting is a matter of intelligence. You can see that in Manet. In every single one of Manet's brushstrokes you can see his intelligence. And this work of intelligence can also be seen in the film on Matisse, where you can watch him draw, hesitate and then express his thoughts in the form of a bold stroke." PICASSO

Paul as Harlequin, 1924
Oil on canvas, 51 1/8 x 38 3/8 in.
Musée Picasso, Paris

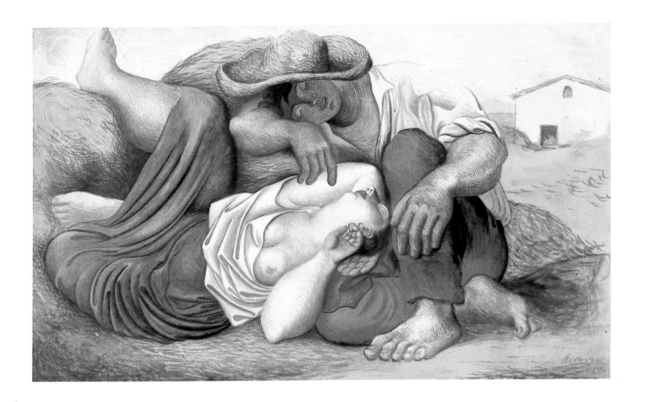

Sleeping Peasants, 1919
Tempera, water-colour and pencil,
12 ½ x 19 ¼ in.
Museum of Modern Art, New York

"Pictures have always been made in the same way that children used to be conceived by the aristocracy: with shepherdesses. You never paint a portrait of the Parthenon, you never paint a Louis XV chair. You paint a picture of a village in the south of France, of a packet of tobacco, of an old chair." PICASSO

In 1918 Olga Koklova changed her name to Picasso. Their marriage also brought about a change in lifestyle. Picasso ceased to cultivate the Bohemian image of an artistic genius and began to display the pride of someone conscious of his superior position as a master painter. The young family moved house, acquired servants, then a chauffeur, and moved in different social circles, no doubt due to Olga's influence. The chaotic artists' get-togethers gradually changed into receptions. Picasso's image of himself as an artist had changed, and this was probably reflected in the more conventional language he adopted in his art, the way in which he consciously made use of artistic traditions and was almost never provocative.

In the summer of 1922, on a holiday in Dinard, Brittany, he painted his "Women Running on the Beach" (p. 53). Their fleshy bodies spread over the whole of the picture, the one on the left in her movement from top to bottom, and the other by stretching from left to right. The robust coarseness of these figures is reminiscent of Picasso's early "Beautiful Dutch Woman" of 1906 (Brisbane, Queensland Art Gallery), but their abundant femininity is a result of Picasso's amazement at Olga's pregnancy. These two anonymous and emphatically female figures can therefore be regarded as a tribute to his own wife. The movement of their hands is modelled on classical examples, rather like the "flagellated" people which he saw in Pompei while he was in Italy. What makes this picture rather complex is the fact that it contains not only elements of motherliness and artistic tradition, but also of the grotesque, motifs

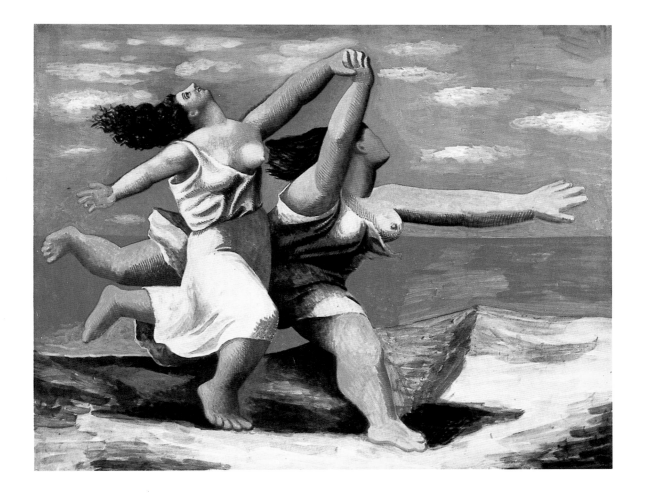

Women Running on the Beach, 1922
Oil on plywood, 13 ⅜ x 16 ¾ in.
Musée Picasso, Paris

which contradict our normal visual experience: for example, the arm which appears to be most in the foreground is the smallest one, while the one at the back is distorted and larger than life; and the horizon is not absolutely straight, but goes up a little, although this is hardly noticeable.

Picasso's "Women Running on the Beach" shows clearly that his decision to paint concrete rather than abstract phenomena, events that can be comprehended, does not mean that he is now rejecting the way in which cubism distorts or questions principles of composition. Picasso's pictures always include both elements. They are an expression of the dynamism with which he constantly tries to go beyond the standard he has reached, continually looking for new forms of expression and oscillating between two poles: the depiction of the real world and the attempt to look beneath the surface. Or, as André Breton, the mentor of surrealism, put it: "The point is that Picasso was the only person who ever went beyond the principles of new artistic methods; his temperament did not allow him to guard them from the vehement bouts of passion in his life." And it was Breton who was the first to publish Picasso's "Demoiselles d'Avignon" in his magazine, thus expressing his respect for

"People keep speaking of Naturalism as the opposite of modern painting. I would like to know if anyone has ever seen a natural work of art. Nature and art are totally different and can never be the same thing. We use art to express our idea of what nature is not." PICASSO

The Pipes of Pan, 1923
Oil on canvas, 80¾ x 68¾ in.
Musée Picasso, Paris

the painter. He did this in 1925 when Picasso seemed to have turned his back on cubism and had started painting more classical pictures.

In 1923, on a holiday in Antibes, Picasso composed "The Pipes of Pan" (p. 55). It is regarded as the most important painting of his "classicist period", not only because of the theme, but also because it combines features which had always been understood as "classical" and which, for centuries, had been seen as normative for judging anyone's artistic merits. Take, for instance, the simple statue-like quality of each figure, consisting of clear, uncomplicated forms, compact like columns, almost motionless like sculptures. The whole picture is stringently self-contained and composed symmetrically, with each figure next to a wall and a glimpse of eternity in the centre of the picture between them. Another element which contributes to the general impression of consistency is the way in which the two figures relate to each other in this scene: the tranquility of the seated musician is counter-balanced by the relaxed position of the other man, who is listening to the music and standing with his feet pointing in different directions. Finally, there is a certain Mediterranean ambience which reminds us of Greek and Roman antiquity and of the origins of everything that is classical. The orderly balance of the picture is no longer disturbed by the grotesque or the chaotic, but permeated by an idyllic, arcadian atmosphere, thus confirming Picasso's ability as a master painter, but almost devoid of any provocative charm. Owing to Picasso's continual desire for variety, his "Pipes of Pan" were to sound the final note of this period in his art.

By contrast, the portrait of his son, "Paul as Harlequin" (p. 50) of 1924, is entirely about private happiness. Picasso created three big portraits of him in all, all of which he kept until he died. In putting the three-year old boy into the costume of a harlequin, he showed again his love for this particular kind of costume, a love which we saw in his Rose Period. At the same time, however, he is admitting his own propensity for slipping into different roles. Its very incompleteness gives the picture an intimate quality: only the head and the hands of the little boy have been finished, the costume looks unreal, as though it had been made for a tailor's dummy, the chair and the background remain sketchy. At the same time, however, the intimacy of the picture is undermined by its format, thus making the boy look larger than life. So, even in this painting, we find that peculiar mixture of the intimate and the monumental which is so typical of this time.

In all these years Picasso followed a personal commitment and emphasised the possibility of taking an everyday phenomenon and projecting an illusion of it onto his canvas. But in doing so, he never lost sight of the other pole of his artistic credo, i.e. his attempt to gain a comprehensive insight into the subject, to penetrate below the surface, to probe into the diversity of everyday life. Whenever Picasso created illusions in his art, he also displayed a certain leaning towards the ornamental and a tendency to follow artistic traditions, and sometimes to be stubbornly conservative and to use his art in a didactic way, like a teacher using the blackboard. His desire for a comprehensive understanding is now beginning to include other characteristics, such as an emphasis on the grotesque, the transparency of forms or their

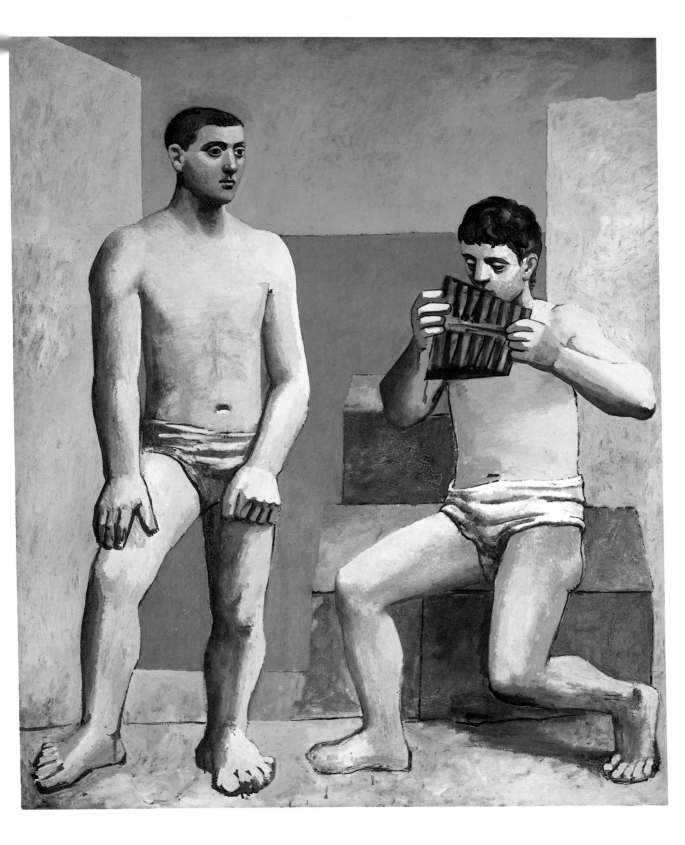

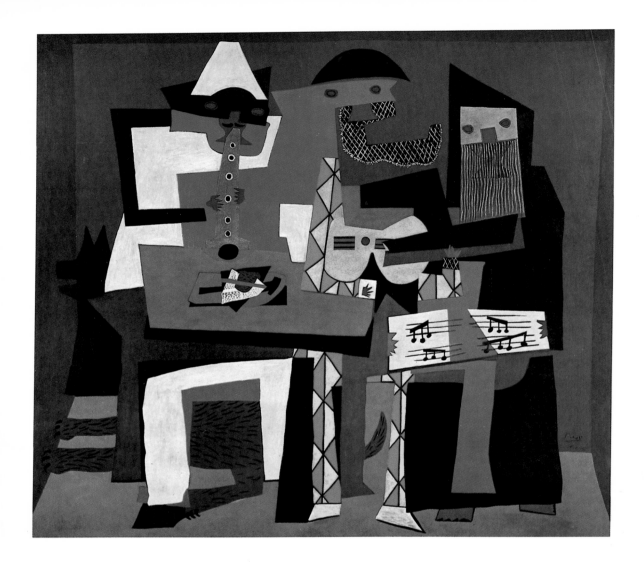

Three Musicians, 1921
Oil on canvas, 79 x 87 ¾ in.
Museum of Modern Art, New York

"Those who set out to explain a picture usually go wrong. A short time ago Gertrude Stein elatedly informed me that at last she understood what my picture 'Three Musicians' represented. It was a still life!"

PICASSO

fragmentation. It is the interrelationship of those two poles which enables us to understand the unity of Picasso's art.

It is therefore hardly surprising that it was not until the summer of 1921, his post-cubist phase, that he painted a picture that came to be regarded as the climax of cubism. In his "Three Musicians" (p. 56) Picasso uses for the first time a group of people as a cubist subject: three figures from the Italian Commedia dell'Arte, a pierrot, a harlequin and a monk playing a trio. The subject is picturesque and traditional, as in his "Sleeping Peasants", and is intricately linked to the fragmentation of the forms that carry the subject. This means that the figures can only be decoded by means of a process of abstraction, of understanding individual signs: the faces hiding behind masks, the feet which can be identified as pairs of angular shapes on the lower edge of the picture, the hands which are depicted as five-pronged objects. Musical instruments

had always been a subject in cubism, and the hands, which are far too small, recall those words of advice that his father gave him and that he never forgot: "The hand can be recognised by the hands." In this picture there are elements which are familiar and recognizable and others which are dissonant and ambiguous. Both kinds form a unified creative whole, and one is tempted to call it "classical", at least within Picasso's art.

Pictures like this bear the hallmark of their creator. Picasso's increasing fame, which also brought about a change in his lifestyle, was partly a result of this synthesis he had achieved. On the one hand, he used to take into account that the onlooker had certain expectations, based on traditional forms of art. On the other hand, however, he also developed his own artistic language. Gradually, quotations of himself became quotations in the history of art, a development which became more and more obvious, the more famous he grew. There comes a point when a work stops being provocative. It was due to Picasso that cubism, which had started off as downright offensive, ended up as part of the classical repertoire. Picasso's fame had become self-perpetuating.

His "Studio with Plaster Head" (p. 57) illustrates this point. It was painted in summer 1925 and contains two recurring themes: a still life and a studio. In this way the picture bears witness to Picasso's constant

Studio with Plaster Head, 1925
Oil on canvas, 38 ⅝ x 51 ⅝ in.
Museum of Modern Art, New York

"I have always painted for my time. I have never burdened myself with searching. I paint what I see, sometimes in one form, sometimes in another. I do not brood, nor do I experiment. When I feel I want to say something, I say it in such a way as I feel I ought to. There are no in-betweens in art. There are only good artists and not so good artists." PICASSO

Seated sculptor and recumbent model in front of window with vase of flowers, sculpted head, 1933
Etching, 7 ⅝ x 10 ½ in.
Plate 63 from Suite Vollard

"It is my misfortune – and probably my delight – to use things as my passions tell me. What a miserable fate for a painter who adores blondes to have to stop himself putting them into a picture because they don't go with the basket of fruit! How awful for a painter who loathes apples to have to use them all the time because they go with the cloth. I put all the things I like into my pictures. The things – so much the worse for them; they just have to put up with it."
PICASSO

Woman with a Flower, 1932
Oil on canvas, 63 ¾ x 51 ⅛ in.
Galerie Beyeler, Basle

habit of introspection, the studio being the place where he would assert himself as an artist, and the still life offering him the best opportunity to demonstrate his artistic virtuosity. Again, he combines relics of cubism and classicism: take, for example, the collage-like table cloth on the one hand, and the bust on the other. Later, fragments of hands and feet are used again in "Guernica" (p. 68-9), the Picasso picture *par excellence*, and the use of scenery as a background occurs again in his late studio paintings.

It seems that in the mid-twenties this development was beginning to become too much for Picasso. He no longer had any control of the way in which society was acclaiming him as an artist. He could paint whatever he liked and had to suffer a public that was gradually suppressing his individuality by blindly applauding every single picture he produced. Added to this, there were marital problems with his wife Olga who enjoyed her role as the wife of a master painter so much that she was unable to give him any support during this crisis. It was due to his vitality that he did not resign himself to this plight: he began to make numerous artistic experiments, set up a sculptor's studio near Paris and tried to rescue his independence by taking an interest in the unknown, the unfamiliar.

"Mademoiselle, you've got an interesting face. I'd like to paint your portrait. I am Picasso". Coming straight to the point, this was how Picasso made friends with Marie-Thérèse Walter in 1927. There was a certain pertness in his request which showed that he was used to being lionized by the public. In the years to come she was to offer him an outlet for his alienation from Olga. His "Woman with a Flower" (p. 59) of 1932 is a portrait of Marie-Thérèse, distorted and deformed in the manner of surrealism, which was so fashionable at the time. Even Picasso could not really avoid being influenced by this group of Parisian artists, although, conversely, they regarded him as their artistic stepfather. With its many analogies between the woman and the flower, the portrait clearly contains surrealist elements: the woman's head and the flower's blossom are both shaped like beans, the blossom coincides with her hair, and the stem with her hand. Thus Picasso is following the principle that each object should be represented by another. The emphasis is not on the ambiguity of form, but its replaceability. Although this idea may find expression in Picasso's picture, it is nevertheless not in keeping with his way of thinking and is to play no more than a secondary role in his subsequent paintings.

His "Interior with a Girl Drawing" of February 1935 is another portrait of Marie-Thérèse. With a second woman crouching in the background, the picture shows a way of modelling faces which was quite typical of that time. Although Picasso had already included profiles and frontal views in his portraits as early as 1913, and although he had already done this in such a way as to superimpose the contours of a profile onto a round head, he was now introducing a far more progressive variation. The girl's head is shaped uniformly in profile, but at the same time it contains both eyes, thus anticipating her frontal view and reversing, as it were, the old principle from his cubist days. Later, Picasso was to make use of both options in his paintings again and again.

Interior with a Girl Drawing, 1935
Oil on canvas, 51 ⅛ x 76 ¾ in.
Museum of Modern Art, New York

"There is no abstract art. You must always start with something. Afterwards you can remove all traces of reality. There's no danger then, anyway, because the idea of the object will have left an indelible mark. It is what started the artist off, excited his ideas, and stirred up his emotions. Ideas and emotions eventually end up as prisoners in his work. Whatever they do, they can't escape from the picture. They form an integral part of it, even when their presence is no longer discernible. Whether he likes it or not, man is the instrument of nature."

PICASSO

Picasso himself admitted that the worst time of his life began in June 1935. Marie-Thérèse was pregnant with his child, and his divorce from Olga had to be postponed again and again: their common wealth had become a subject for the lawyers. During this time of personal crises Picasso would supplement his arsenal of artistic weapons in the form of a bull, either dying or snorting furiously and threatening both man and animal alike: being Spanish, Picasso had always been fascinated by bull fights, by the "tauromachia". At the same time he was adopting the mythological figure of the Minotaur into his repertoire. There had been some first attempts shortly after his stay in Italy, but it was the Freudian psychology of the surrealists that provided him with a means of identification. The Minotaur is the clue to our understanding of the fringe-like figure of an artist who is torn between the gratification of his impulse and the demands of society.

Picasso's "Bathers with a Toy Boat" (p. 61) of February 1937 is one of his key paintings during this profound time of crises. "I am writing to you immediately to let you know that as from tonight I shall give up painting, sculpting, etching and poetry, and I shall devote myself to singing instead." These were the words Picasso wrote to his old friend Jaime Sabartés, whom he knew from his days in Barcelona. Well, he did not sound the retreat. It was no more than an understandable but momentary phase of depression.

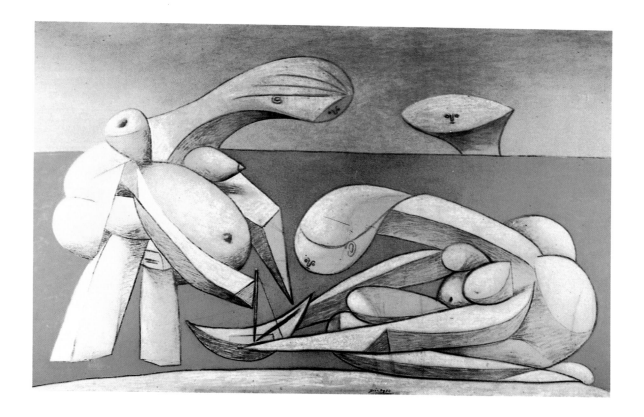

The pictures he was painting at this time speak of bewilderment and perplexity. Again and again, even as early as his summer holiday in Cannes in 1927, he would paint bizarre scenes of bathers, where the familiar, everday figure of the holiday-maker has disintegrated into soft, amoeba-like forms. What is striking about his bathers of 1937, however, is their hard and angular forms. Although the sexuality of the figures, with their pointed breasts and broad buttocks, is sufficiently emphasized, they do rather look like crude wooden sculptures hewn out by a dilettantist. As before, there are elements of surrealism, and this picture was in fact the last one in which the surrealist influence was so strong. Surrealism also accounts for an obvious narrative inconsistency, i.e. the question why adult women should be playing with a child's toy.

The scene would almost be realistic, were it not for the threatening element of the head in the background. If we read the blue strip as the sea – an interpretation which is also suggested by the boat and the title – then the head is that of a monstrous figure on the horizon, gruesome and horrible because of its enormous size. But we can also read the patch of blue as a wall, with a head looking over it – an interpretation which is based on the principle that one can never look beyond the horizon. This would throw doubt both on the reality of the figures in the foreground and on the title. None of Picasso's pictures express so much futility and despair. There is a certain destructiveness about the ambiguity of this

Bathers with a Toy Boat, 1937
Oil, chalk and charcoal on canvas,
50 ⅜ x 76 ¾ in.
Peggy Guggenheim Collection, Venice

"I keep doing my best not to lose sight of nature. I want to aim at similarity, a profound similarity which is more real than reality, thus becoming surrealist."
PICASSO

"Everyone wants to understand art. Why don't we try to understand the songs of a bird? Why do we love the night, the flowers, everything around us, without trying to understand them? But in the case of a painting, people think they have to understand. If only they would realize above all that an artist works of necessity, that he himself is only an insignificant part of the world, and that no more importance should be attached to him than to plenty of other things which please us in the world, though we can't explain them. People who try to explain pictures are usually barking up the wrong tree."

PICASSO

Portrait of Dora Maar, 1937
Oil on canvas, 36 ¼ x 25 ⅝ in.
Musée Picasso, Paris

painting: either it contains the very negation of the title and the narrative, or it is a horror vision of unimaginable size.

With his "Portrait of Dora Maar" (p. 63) Picasso was beginning to approach "Guernica". She was a Yugoslavian photographer whom Picasso got to know in 1936 through his friends Paul Eluard and Georges Bataille. Later, during the war, she became his constant companion. The simultaneous rendering of frontal view and profile acquires a classical balance in the relaxed serenity of her face. And even the collar of her dress and the chair are depicted simultaneously from the front and the side. Nevertheless, this seeming orderliness is disrupted by some elements of tension. The different colours of her eyes could still be understood as the painter's playful but deliberate distortion, but the encasing of the figure in a narrow box already points to his war paintings. It expresses a fear of confinement, i.e. claustrophobia. At this stage, however, Picasso's subject is still utterly and completely balanced and beautiful.

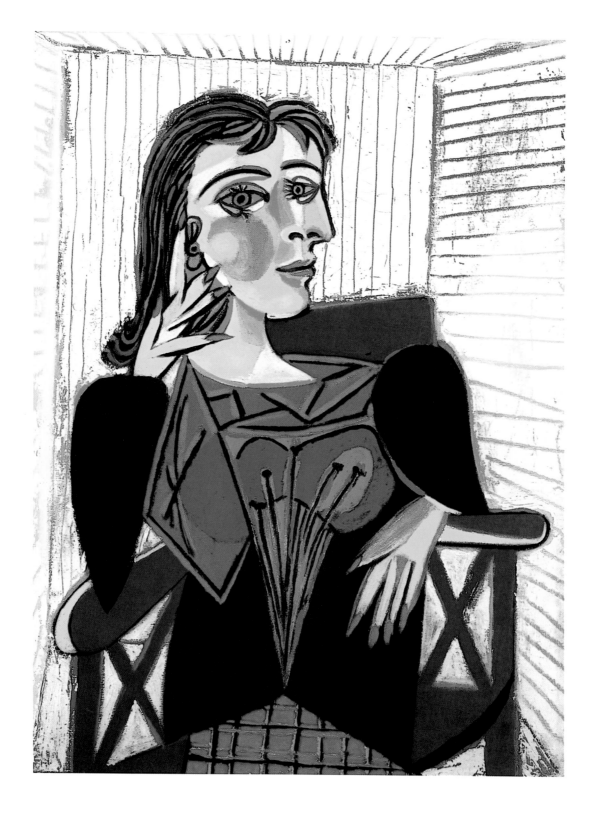

Picasso's Posters

In October 1945 Braque introduced Picasso to the Parisian printer Fernand Mourlot. Because of the war, Picasso had not been able to make use of the printing press for years, but now he was allowed to use Mourlot's studio in the Rue Chabrol and so he soon spent whole days there – often from early morning until late evening. During the next three and a half years he made more than two hundred lithographs there. He really had great fun with his carbon paper, India, crayon, brush and scraper and he used to enjoy transferring the plate onto the stone. Again and again he thought of new techniques which the old hands at the workshop could only look upon with sympathic smiles, shaking their heads. Imagine their surprise when they realized that, with a lot of patience, these ideas

could actually be put into practice after all. It was in Mourlot's studio that Picasso soon began to produce his first posters. A poster is a medium which aims at combining a short, concise piece of information with a picture that is both simple in its message and can be remembered easily. However, Picasso did not just use posters for invitations to his own exhibitions. But after he had joined the Communist party, they seemed virtually predestined to serve his involvement in the worldwide cause of peace. The dove had already been a symbol of his aspirations when he was a little boy in Málaga, and now it was to achieve worldwide fame as a symbol of peace. His poster for the World Peace Congress in Paris, April 1949, was printed in Mourlot's workshop. When Louis Aragon was paying a brief visit to Picasso's studio in the Rue des Grands Augustins he discovered a lithograph which had been made recently, and so he

decided spontaneously that it should become the motif for the congress poster and suggested it to the committee.
Another person who influenced Picasso's posters was the printer Arnéra in Vallauris. This was the place where in 1946 he had begun to produce his ceramics in the workshop of the Ramiés, a married couple, and where in 1948 he rented the villa "La Galloise" and lived together with Françoise. Arnéra suggested to him that he should try his hand at lino-cuts, and this was the technique he used for a number of bull-fight posters and also for his own exhibitions. The place-name always formed part of the title. His Poster for an exhibition in 1952 shows the profile of a billy-goat, almost a portrait of his bronze

World Peace Congress, 1949
Lithograph, 23 ⅝ x 15 ¾ in.
and 42 ¼ x 31 ½ in.
printed by Mourlot, Paris 1949

Vallauris Exhibition, 1952
Coloured lino-cut, 26 x 20 in.
poster format 31 ½ x 26 ⅜ in.
printed by Arnéra, Vallauris, 1952

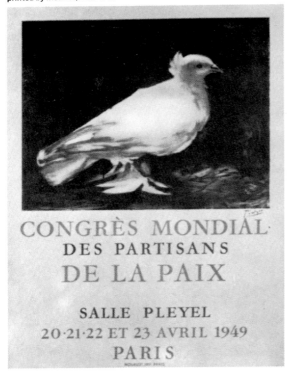

Bull-fight at Vallauris, 1959
Coloured lino-cut, 25 ¾ x 21 in.
poster format 30 ¾ x 22 in.
printed by Arnéra, Vallauris, 1959

Bull-fight at Vallauris, 1960
Coloured lino-cut, 25 x 20 ⅞ in.,
poster format 29 ½ x 24 ¾ in.,
printed by Arnéa, Vallauris, 1960

sculpture "The Nanny-Goat" (p. 48) which he had made in Vallauris in 1950. It was one of his favourite themes. The picture in the centre was the important motif, and so the writing was designed round or in it: the word EXPOSITION fills the empty space above the head, thus fitting round it very gently and allowing the artist to write in a special kind of script. VALLAURIS, which is below the head and extends into it, had to be modelled differently to fit in with the goat: the letters are shaped very much like the shaggy beard of the goat, thus giving an idea of the goat's hide, without actually explicitly depicting its texture. The writing in the poster is less important than the number. To put the year 1952 – framed by a wreath-like 0 — into the middle and at the top, the preceding letters had to be spread out a little and the ones after the 0 squashed together.

The successful synthesis of text and picture which Picasso achieved can be seen very clearly in two posters made in 1959 and 1960, respectively. Both must be seen as variations on the same theme. Both aim to inform: "Toros en Vallauris". The bull-fight has been and still is a traditional ceremony that is very much alive both in Spain and – though in a slightly more restrained form – in the south of France. It is also a recurring theme in Picasso's pictures. In his poster of 1959 we can follow the different stages of a bullfight in various scenes.

The letters of the word TOROS EN are like openings in a wooden fence, affording us a glimpse of the fighting scenes, sketched with only very few strokes of the pen. The almond-shaped framing of the scene in the upper half of the T (and of the R) can be read either as the arena or the eyes which reflect it, or even as the eye which is looking at the scene. Conversely, the eye that looks at us through the 0 from the other side of the fence gives us an idea of the distance of the small figures. Thus, although there is no traditional perspective, Picasso's playful use of different directions creates the impression of space behind a wall. The combination of text and picture is well balanced in this poster, because the letters serve two purposes at a time, i.e. that of giving us information and also of showing us some symbolic pictures.
This was an important principle in Picasso's posters, but when he made another poster for the same occasion a year later, he reversed the principle, giving text and picture the same degree of importance, with the bull fight scenes framing the letters. This distribution means that, to get the information out of the poster, our eyes have to follow the movements of the bull, which contain the various syllables. It is worth nothing that, for his posters, Picasso used coloured lino-cuts far more frequently than lithography (even though the latter is simpler and cheaper), or reprographics. In this

respect, Picasso was the exception among his contemporaries. Twentieth century artists, generally avoided lino-cuts. Lino yields less lively results than wood (hardly ever used by Picasso), because it does not have the vein-like streaks, but it has its advantages which Picasso knew how to exploit. Planes that have been scraped out "untidily" let the surface which has been worked on shine through thus reducing the contrast between light and darkness. Overlapping patches of colour make for more gentle transitions, although, if treated in the right way, it is also possible to create clear contrasts in a picture. This can be seen in his exhibition poster of 1952. Picasso's skillful use of the specific properties of the lino-cut meant that it became far more widespread in the twentieth century than it would have done otherwise.

Picasso's Wartime Experience
1937 – 1945

"Guernica, the oldest town of the Basque provinces and the centre of their cultural traditions, was almost completely destroyed by the rebels in an air attack yesterday afternoon. The bombing of the undefended town far behind the front line took exactly three quarters of an hour. During this time and without interruption a group of German aircraft – Junker and Heinkel bombers as well as Heinkel fighters – dropped bombs weighing up to 500 kilogrammes on the town. At the same time low-flying fighter planes fired machine-guns at the inhabitants who had taken refuge in the fields. The whole of Guernica was in flames in a very short time."

This was published as a cool and detached eye-witness account of the Spanish civil war in The Times on 27th April 1937, and if this event had been mentioned in the heroic annals of the rulers of this world, there would have been no more than a cynical and macabre footnote of some insignificant skirmish somewhere. But it was Picasso's interpretation, his translation into the medium of a painting, that gradually turned it into an event of the century. Picasso understood it as a fascist experiment to prepare the end of the world and mercilessly brought it down to the level of his own experience. The value and authenticity of the picture is achieved not by means of historical accuracy or a simple re-telling of what happened, but through the unceasing timelessness of suffering.

Picasso's "Guernica" (p. 68-9) depicts a historical event in a manner still permitted by the age of artistic autonomy: instead of giving an eye-witness account, the painter renders his own personal horror. The picture is not so much about a historical fact, but rather its effect on Picasso's innermost being.

"Screaming children, screaming women, screaming birds, screaming flowers, screaming trees and stones, screaming bricks, furniture, beds, chairs, curtains, saucepans, cats, paper, screaming intermingling smells, screaming smoke hitting you on your back, screams stewing in a big cauldron, and the screams of birds falling like rain on the sea and inundating it." These are Picasso's own words with which he concluded a poem on his series of etchings "Franco's Dream and Lie" at the beginning of 1937. This was his first comment on the Civil War between Republicans and Fascists that was raging in his native Spain. But even in this real torrent of violent verbal imagery there is nothing

Weeping Woman, 1937
Ink, 9 ⅞ x 6 ¼ in.

"People want to find a 'meaning' in everything and everyone. That's the disease of our age, an age that is anything but practical but believes itself to be more practical than any other age." PICASSO

Weeping Woman, 1937
Oil on canvas, 23 ⅝ x 19 ¼ in.
Penrose Collection, London

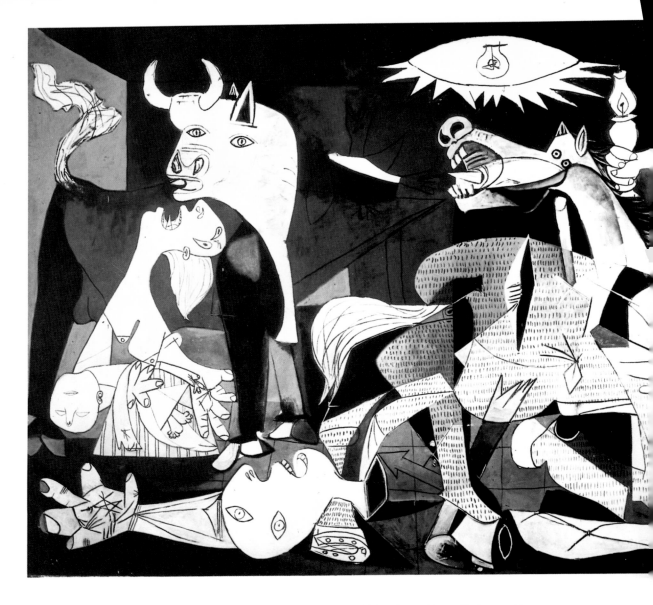

anecdotal. Instead, it is still dominated by suffering and horror, not as a
momentary phenomenon but the ever-present dark side of human life.
This is the sense in which Picasso's art always has a certain tendency
towards the mythical, with an emphasis on timeless truths rather than
sensational eye-witness accounts.

And yet, when "Guernica" was painted in May/June 1937 it was
regarded as extremely topical. In January Picasso had been asked by the
official Republican Spanish government to contribute a monumental
painting to their national pavillion at the World Exhibition in Paris that
summer. Although he disliked the idea of taking on commissions, he
decided to depict the theme "painter and studio". This would have been

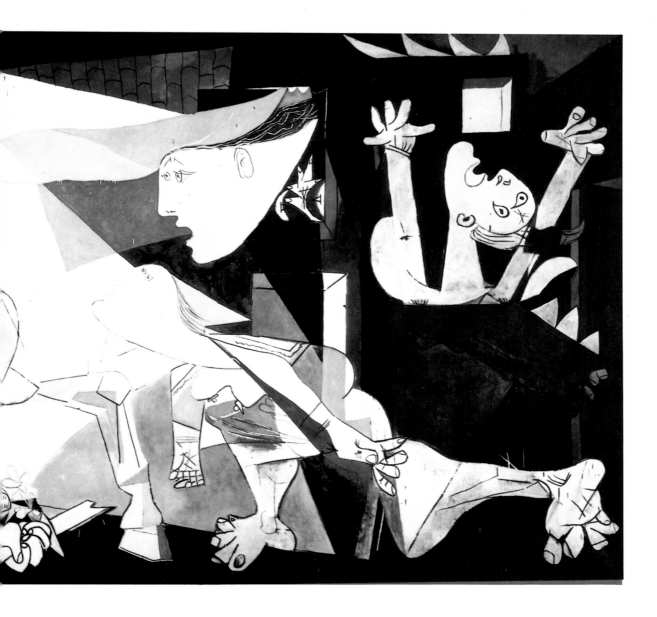

Guernica, 1937
Oil on canvas, 11 ft 5 ½ in x 25 ft 5 ¾ in.
Museo de Prado, Madrid

entirely in keeping with artistic development. But when he heard of the bombing of Guernica, he rejected his original idea of paying homage to private creativeness: it would have been no more than a conversation about the weather, almost a crime, in fact, because it would have kept silent about the crimes that had been committed.

So this is how, after numerous sketches and studies, Picasso gave his own personal comprehensive view of a historical fact which was expressed in the title of the picture and certainly present in the minds of his contemporaries, and he did this by means of a subjective analysis in the formal language of art. As before, one of Picassos's typical features is his use of quotations from other works of art, such Hans Baldung Grien's

Study for "Guernica", 1937
Pencil, 90 ½ x 11 ⅜ in.

Girl with a Boat (Maya Picasso), 1938
Oil on canvas, 24 ½ x 18 ½ in.
Rosengart Collection, Lucerne

"Bewitched Groom" or the figures on the roofs of Greek temples, especially in the composition of triangles at the centre of the picture, or quotations of himself, for example the figure of the fallen warrior in the bottom left-hand corner. Nevertheless, he still remained close to his actual commission, as can be seen in the way he included a reference to the tiled floor in the Spanish pavillion.

Guernica has remained part of the collective consciousness of the twentieth century, because "Guernica" has been serving as a forceful reminder of it. In 1981, after forty years of exile in New York, the picture found its way back to Spain. This was because Picasso had decreed that it should not become Spanish property until the end of Fascism. Spain had acquired a national symbol. It is now in the Prado Museum in Madrid, where it is watched over and guarded like the gold of the Bank of England.

The extent to which surrealism gave Picasso new ideas was very limited. Surrealism invited the artist to practise introspection, to set free the forces of his innermost being, and this was not acceptable to Picasso who was interested in concrete, everyday reality. It is true, though, that even Picasso often tended towards introspection and self-observation in his art, particularly when he was going through a personal crisis. On the whole, however, Picasso always remainded a realist. Ever since "Guernica", if not before, he felt that concrete events had made a nonsense of any plans of delving into the depths of his soul. An overwhelming number of war experiences as well as tension and friction in his own life convinced him that he should turn to themes outside his own self again. The years to come provided an extremely suitable subject for comments of a political kind.

In October 1937 Picasso painted the "Weeping Woman" (p. 66) as a kind of postcript to "Guernica" and based on sketches for the mother and child (top left). The contemporary theme of suffering has been condensed into one single head which is looked at from very close. At first sight the picture seems to be dominated by a number of purely artistic elements: there is a pleasantly colourful background, the woman is wearing a rather attractive summer hat, and her face is depicted both in profile and as a frontal view – a technique which we already know from many other of Picasso's portraits. But, whichever way we look at it, the centre of the painting is occupied by the angular shape of the handkerchief which serves as a metaphor of suffering in general. The woman is biting it in her despair, and it is catching the tears that are pouring violently from her eyes. Even her finger-tips seem to be turning into tears as soon as they get moist. The handkerchief veils her mouth, thus revealing the vehemence of her pain, and with its contrast of blue and white points to "Guernica". The whole tragedy of suffering is contained in the contrast beween head and handkerchief.

It almost seems as if Picasso went a little too far in his ambitions this time. The most important element of his cubist pictures, for instance, used to be the contrast between an everyday subject and the destruction of the form that carried it. Now, however, the destruction had been doubled. Destroyed form, a typical feature of Picasso's art, now also had to carry the ideas of destruction, fragmentation and confusion. One feels

Skull of a Sheep, 1939
Gouache, 18 ¼ x 24 ¾ in.

"The different styles I have been using in my art must not be seen as an evolution, or as steps towards an unknown ideal of painting. Everything I have ever made was made for the present and with the hope that it will always remain in the present. I have never had time for the idea of searching. Whenever I have wanted to express something, I have done so without thinking of the past or the future. I have never made radically different experiments. Whenever I have wanted to say something, I have said it in such a way as I believed I had to. Different themes inevitably require different methods of expression. This does not imply either evolution or progress, but it is a matter of following the idea one wants to express and the way in which one wants to express it."
 PICASSO

Still Life with Steer's Skull, 1942
Oil on canvas, 51 ⅛ x 38 ⅛ in.
Kunstsammlung Nordrhein-Westfalen,
Düsseldorf

inclined to call this a tautology. It is a phenomenon which pervaded quite a number of pictures he painted at this time. Although these paintings do indeed succeed in emphasizing the forceful impact of pain, one feels tempted to ask if Picasso's striving for complexity might not undermine the simple immediacy of pain.

"There you are, I'm not just interested in dark things." – Having painted several portraits of his daughter Maya, Picasso reminded a good friend of his not to over-emphasize the theme of suffering in his art. His "Girl with a Toy-Boat" (p. 71) of January 1938 seems to be quite ordinary. The theme of this painting is childlike innocence: untroubled by the world, a little girl with big eyes and pigtails is playing with a toy boat. This and a naive style, which is based on children's drawings, make for a naive boisterousness hardly in keeping with the times. But it was the time he spent with his family, i.e. Marie-Thérèse Walter and their little daughter, that lent him support for the production of those big artistic masterpieces that were demanded of him by the general public.

In August 1939 both Picasso and Europe had their last beautiful summer for many years to come. This is why his painting "Night Fishing at Antibes" (p. 74) has an atmosphere of that idyllic cheerfulness which Picasso valued so much in the pictures of his old friend Henri Rousseau. This almost anecdotal fishing scene at full moon was used by Picasso for playing with harmonies of light and colour. His accurate rendering of the lights attracting the fish and the fishermen harpooning the sea creatures with their pronged spears brings to mind his tendency towards the traditional, a tendency which he had almost lost for a while. But this first impression may be deceptive? Does this dream-like nocturnal scene not also have a frightening and ghost-like quality about it, caused by an unsual colour scheme which is not really typical of Picasso? Blue, black and several shades of green mingle with a cheerless brown and dark violet which engulf the town of Antibes in the top left-hand corner of the painting. At the same time the paleness of the faces seems to be indicating a general fear of the impending disaster.

For the following six years Picasso had to do without the Mediterranean. Paris was occupied by the Nazis, and Picasso had to practise his art under conditions of confinement. For decades he had already been living in exile and had proved to be extremely productive because of it. Now, however, he had to live without any publicity for a number of years. "Internal emigration" became a byword for caution and discretion among artists during the time of Fascism, and more than ever before Picasso's art was becoming a means of survival, comparable to people like Max Beckmann and Otto Dix who were living in Amsterdam and on Lake Constance, in similar niches within the empire that was claimed by the new rulers. It was during this time, in April 1942, that he painted his "Still Life with Steer's Skull" (p. 73). The table, the window overlooking an unfathomable darkness, and a general atmosphere of barren wretchedness serve to direct one's attention even more towards the sterile bones and the hollow depths of the skull. Perhaps there was such a scarcity of food that Picasso simply did not have any suitable objects to paint a traditional still life, a table covered with an abundance of all kinds of foodstuff. Perhaps the painting is simply a

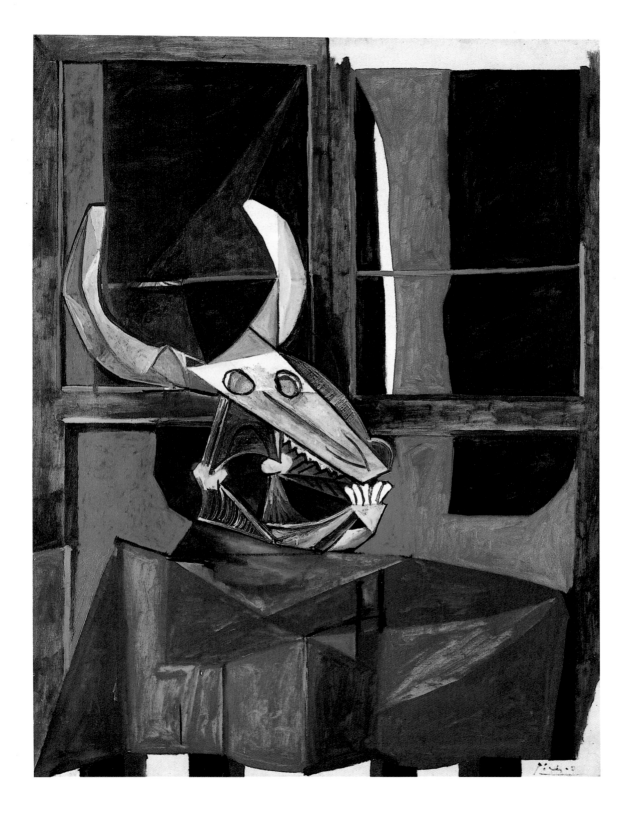

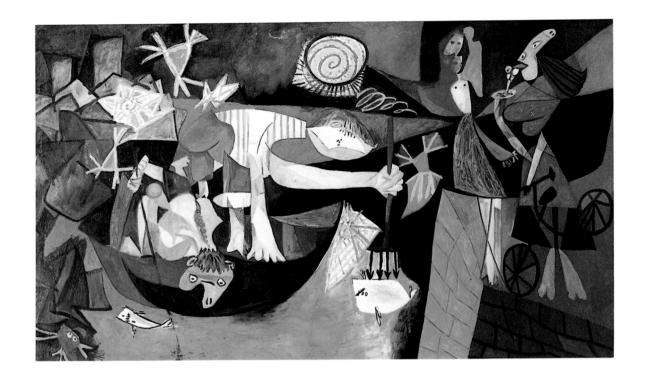

Night Fishing at Antibes, 1939
Oil on canvas, 81 x 135⅞ in.
Museum of Modern Art, New York

document of hopelessness. The picture was painted on the same day that he received news of the death of his old friend Julio Gonzalez, a fellow sculptor who used to join him in many of his experiments in Boisgeloup. There are two ways in which suffering appears to be taken for granted in this painting: his grief over his friend's death and his despair of the times unite in a cheerless memento mori that could not have been formulated more desperately by any of the Christians of the Middle Ages.

But the final chord of this period in Picasso's art was still to be played. With the liberation of Paris in August 1944 Picasso was given back to the general public, who welcomed him even more than before: for a long time people had been cultivating an image of Picasso as a true artist, but in addition they could now also admire the moral purity he had displayed during the days of occupation. He had always refused to flirt with the Nazis, and the pressure of a politicized public as well as his own views made him join the Communist Party of France in the same year. After all his experience Picasso felt that there was no contradiction between the radical individualism he had always cultivated and the idea of social concern.

With his "Charnel House" (p. 75) of 1945 Picasso concluded the series of pictures which he started with "Guernica". The relationship between the two paintings becomes immediately obvious when we consider the rigidly limited colour scheme and the triangular composition of the centre. But the nightmare has now been overtaken by reality itself. "The Charnel House" was painted under the impact of reports from the concentration camps which had been discovered and liberated. It was

not until now that people realized how many monsters had been born while reason slumbered. It was a time when millions of people had been literally pushed to one side – a turn of phrase which Picasso expressed rather vividly in the pile of dead bodies in his "Charnel House". The destruction of form and the stretching, or even torturing, of subjects were taken one step further. It seemed that "Guernica" with its ruthless artistic technique had still not been bold enough, because it had now found its counterpart in real life.

The theme of death had been a key to an understanding of Picasso's subjects ever since his friend Casagemas' suicide at an early age. In "The Charnel House" this theme is, as it were, taken to its logical conclusion. There had been a lot of talk about the unity of life and art, but Picasso could not have shown it with more cynicism.

"Is there anything more dangerous than being understood? All the more so, as there is no such thing. You are always misunderstood. You think you aren't lonely, but in actual fact you are even more lonely." PICASSO

The Charnel House, 1944/45
Oil and charcoal on canvas, 78 ⅝ x 98 ½ in.
Museum of Modern Art, New York

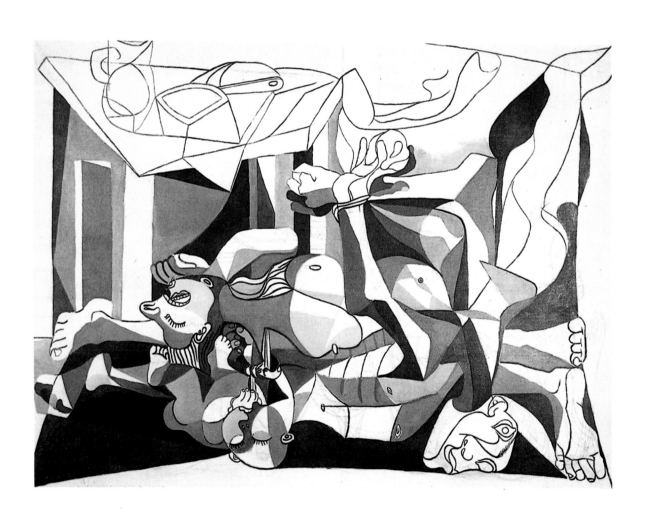

Picasso's Ceramics

Picasso's ceramic art is inextricably linked with Vallauris, that little village in Provence. It was in 1936 that he visited it for the first time, together with his friend the poet Paul Eluard, on a car tour. It is situated near Cannes, and ever since Roman times there has been a lot of pottery there. By the 1930s, however, a great number of workshops had had to close down, because their traditional craft had ceased to attract customers.

It was not until after the war, in 1946, that Picasso remembered Vallauris again, visited it and made friends with a married couple who were both potters, Mr and Mrs Ramié. He modelled some small figures in their workshop "Madoura" and found that they were still there a year later. Picasso continued to maintain this link for ten years. At first he would work in the Ramiés' workshop, then he moved into a more spacious studio of his own in an empty perfume factory, and eventually he settled down in a villa just above the little town. In his first years alone, working together with the local potters, Picasso created nearly 2000 ceramic works of art. Picasso had found a new playground, as it were, in Vallauris. And being extremely versatile, it is hardly surprising that he refused to confine himself to the same old media, but was constantly looking for new ways of expressing himself. Whenever he had found something new, he would be as enthusiastic about it as a child about his first toy car. And so ceramics was just right for him – an ancient craft with a long tradtion which had until then been avoided by painters and sculptors. It is true, of course, that Henri Matisse and other Fauve artists had taken an

Plate: Picador with Shying Horse, 1953
14 ⅜ x 14 ⅛ in.

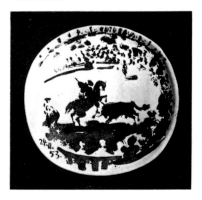

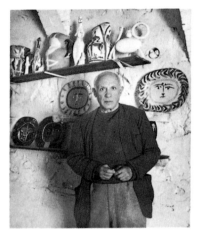

Picasso at Vallauris, 1947

active interest in pottery, but they were mainly concerned with decorating ready-made but untreated pieces.

In fact, that was what Picasso did at first: he took some plates, bowls, pots and jugs – familiar props from numerous still lives – and adorned them with coloured glaze, thus giving a completely novel appearance to some simple, everyday objects. For example, an ordinary plate – formed in the traditional way by the potter – would change in his hands into an arena for a bull-fight. A few spots of paint would turn the edge of the plate into the rows of spectators who were watching the spectacle in the arena, the bottom of the plate, where the torero and the bull were about to have their encounter. Thus, by using the specific shape of a plate and painting it in a certain way, Picasso accomplished the metamorphosis from

Recumbent Blue Dove, 1953
9 ½ x 5 ½ in.

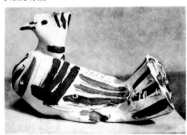

an everyday article into a work of art. With only very little brushwork he turned a traditional and highly functional object into a painting. But Picasso was merely showing something in his art that was already part of everyday language: after all, we talk about the neck and body of a vase in the same way as we talk about the neck and body of a person. When a piece of pottery is painted, it becomes an image, in other words a sculpture. It was now a logical consequence for Picasso to start modelling the shapes as well. He started off by pressing together and bending an article that was still wet and supple and had just come from the turntable. The strict symmetry was loosened up, the surface lost its smoothness, and the material itself with its specific properties came into its own. This is how a compressed vase, for instance, turned into a kneeling woman. Doves were a favourite and constantly recurring motif in Picasso's art. He had known them from his father's easel in the days of his childhood. Later, in his paintings and his graphic art, such nature studies turned into appeals for peace. And Picasso cultivated the same motif in his ceramic art, as a decoration on plates and bowls, or a clay figure which he moulded himself, bringing it to life with his own hands as a sign of his inexhaustible creative energy. Picasso's friend Jean Cocteau said about his doves: "You wring their necks, and they come to life".

Owl Vase, 1951
Vase with two handles; parts were formed on turntable and then put together; decor was engraved with Engobe glaze,
ca. 22 ½ x 18 ½ x 15 in.

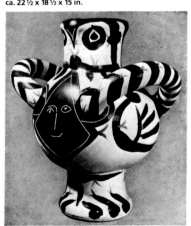

Titles: Head of a Woman, 1956
White clay, decorated and glazed with pastel,
24 x 24 in.

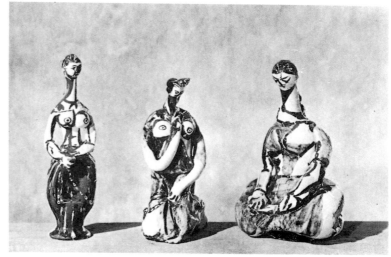

Bottles: Standing and Kneeling Women, 1950
White clay, formed and modelled on the turntable;
oxydation on white enamel. Figure on the left: 11 ⅜
x 2 ¾ x 2 ¾ in.
Figure on the right: 11 ⅜ x 6 ⅝ x 6 ⅝ in.

Owl, 1952
White clay, cast and decorated with Engobe and
pastel; 13 ¼ x 13 ⅝ x 9 ⅞ in.

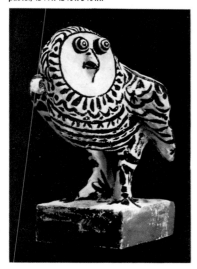

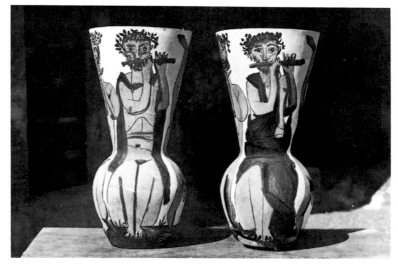

Clay vase, Painted with Nude and Clothed Flute
Players, 1950
Formed and modelled on the turntable; height ca.
24 in.

The more Picasso became familiar with this new material, the more he became enthusiastic about it and wanted to try out new techniques. At first he would cut into or scrape the leather-like surface of the clay, or add more pieces to it so that it became like a bas-relief. Finally he treated them like collages and stuck several parts of different vessels together. The original shapes of the earthenware articles were hardly recognizable any longer.
Having established his own studio in Vallauris, Picasso began to paint tiles. The ceramic product only functioned as the background of the picture, of course, but Picasso was extremely fond of this technique because glaze, unlike oil, does not change its quality after a number of years. He often combined several tiles in a large picture, so as not to be dependent on the limited format of one tile. It was thanks to Picasso that pottery experienced a revival in this little town. The Ramiés produced a number of replicas of original Picasso pieces, which were very popular and sold well. Year after year, the artist's birthday was celebrated in a big festival, the climax of which used to be a bull-fight at the local arena. Picasso and his children used to attend such events quite regularly, and on his birthday he would be given a place of honour.

The Late Works
1946 – 1973

In the end he starved to death: Midas, the legendary king of the Phrygians was granted a request by the gods that everything he touched would immediately change to gold. Everything – and that included food and drink. This ancient Greek myth was a warning not to strive too much for worldly possessions. "If Picasso is said to have Midas' ability, then that is literally true, because the recognition of his talent might mean that whenever his pencil touches the paper, the most insignificant scribbling can turn into gold." These are the unsurpassed words of admiration with which Picasso's biographer Penrose describes the mythical tendencies of his idol. However, Picasso did not starve to death. Was Picasso himself a myth, a myth with a happy ending?

In summer 1945, Picasso finally grew tired of that claustrophobic existence he had led in Paris for so many years, and he decided to buy an old house in the provincial village of Ménerbes. His Midas touch did not fail him: he was given the chalet in exchange for a still life. He could acquire anything he wanted simply by painting or drawing, not as a gift from the gods, but rather as a result of his international reputation. But even the myth about Picasso had its moral element: Picasso was not afraid of starvation, but of publicity, and the price he had to pay was loneliness, because the further he withdrew, the more people were filled with awe of his genius. Picasso's post-war masterpieces therefore seem like one enormous withdrawal symptom. Except in very few cases, Picasso no longer made any public comments, and the tremendous number of pictures he painted at this later stage of his life increasingly reflected his own life. And this was the life of an artist who had become public property.

A whole chapter of Picasso's autobiography in paintings is dominated by pictures of his studios. Paris brought back too many memories of the narrowness of his life during the war, so in summer 1955 he bought "La Californie", an impressive 19th century stately home near Cannes, overlooking Golfe-Juan and Antibes, where he had spent many a summer. From his studio he could see his enormous garden, which he filled with his sculptures. The south and the Mediterranean were just right for his Spanish mentality and enabled him to escape the stream of fawning visitors who had become such a nuisance.

His "Studio 'La Californie' at Cannes" (p. 80) of March 1956

Pan, 1948
Lithograph, 25 ⅝ x 20 in.

"Nothing has ever been created without loneliness. I have created a loneliness for myself which nobody can see. It is very difficult nowadays to be on your own, because there are clocks and watches. Have you ever seen a saint with a watch? I have never been able to find any, not even among those saints who are regarded as patron saints of the watchmakers." PICASSO

Cavalier with Pipe, 1968
Oil on canvas, 57 ¼ x 38 ⅛ in.
Galerie Rosengart, Lucerne

The Studio "La Californie" at Cannes, 1956
Oil on canvas, 44 ⁷⁄₈ x 57 ½ in.
Musée Picasso, Paris

"You can really only ever work against
something. Even against oneself. That is
very important. Most painters get out their
little cake-tins and then they start making
cakes. The same cakes, again and again.
And they are very happy with them. A
painter should never do what people
expect of him. Style is the worst element of
the painter. Art does not find its style until
they are dead. It is always stronger."

PICASSO

really shows the artist's cathedral, the sanctuary in which he kept his
artistic wonders. It is part of the atmosphere in this picture that one can
imagine the painter going on an adventure trip into his own imagination
and exploring the remotest corners of it. But at the same time the
painting depicts a complex world of its own in that it contains the artist's
view of art. For instance, the empty canvas on the easel in the middle of
the picture is also the unpainted piece of canvas of the whole studio
picture; and the view of the palm trees as well as the window-sill seem to
form an organic whole with the world of the paintings that lean against
the window-sill. The theme is "painting within a painting", which means
that this picture of Picasso's studio is more than a self-portrait in the form
of a room. He also used his art to show different kinds of realities and to
play with them, as it were.

Ten days later Picasso painted "Jacqueline in the Studio" (see above),
thus taking his play on distorted realities one step further. This time it was
a matter of taking as his subject a picture which he had painted himself,
i.e. his "Studio at Cannes". This can be seen both in the title and in
elements such as the samovar, the table, the view from the window. Then

there is Jacqueline's profile, the woman whom Picasso was to marry five years later, when he himself was already quite advanced in age. There is something rather ambiguous about Jacqueline in this picture: is she really sitting in a wicker chair, or is her head just part of the painting in the background, on an otherwise empty piece of canvas? Probably, this interior was not actually influenced by Henri Matisse, as some people think. Nor should it be looked at in terms of large patches and an ornamental style. Rather, it shows his great sensitivity towards Art and his use of mannerist style in deliberately confusing the onlooker with conflicting realities.

One could, of course, disqualify it as "l'art pour l'art" and accuse Picasso of producing something rather affected and artificial, if one did not know about Picasso's tragic tilting at the windmills of public opinion – tragic because it was bound to fail. Picasso's confusion of realities in his pictures also seemed to reflect his own state of mind: Picasso as a figure head, Picasso as a spoiled brat, Picasso as the victim of the hounds of sensationalism who were only interested in his fame, but completely indifferent to what was going on in the art world at the time. Thanks to

Jacqueline in the Studio, 1956
Oil on canvas, 44 7/8 x 57 1/2 in.
Gift from the Galerie Rosengart to the city of Lucerne

"When you begin a picture, you often make some pretty discoveries. You must be on guard against these. Destroy it, do it over several times. With each destruction of a beautiful discovery, the artist does not really suppress it, but rather transforms it, condenses it, makes it more substantial. What comes out in the end is the result of discarded finds. Otherwise you become your own connoisseur. After all, I don't buy my own pictures." PICASSO

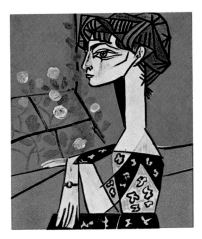

Jacqueline with Flowers, 1954
Oil on canvas, 39 ⅜ x 31 ⅞ in.
Jacqueline Picasso Collection, Mougins

"I deal with painting as I deal with things; I paint a window just as I look out of a window. If an open window looks wrong in a picture, I shut it and draw the curtain, just as I would in my own room. In painting, as in life, you must act directly. Of course, painting has its conventions, and it is important not to ignore them. In fact, you can't ignore them anyway. And so you should never lose sight of real life." PICASSO

The Doves, 1957
Oil on canvas, 39 ⅜ x 31 ½ in.
Museo Picasso, Barcelona

magazines, books and films, people knew every single trouser button of the mature Picasso. He was more popular than every before, but his art was given very little attention and was regarded as no more than the hobby of an ageing genius who could do nothing but talk about himself in his pictures. It may have been partly due to the way in which his whole person was claimed by the public that, in his late works, Picasso kept revolving round the subject of art.

It had always been an essential part of Picasso's creative process to go into the history of art and to make clever use of elements that were in fact quite traditional. In his youth, these traditions helped Picasso to find his own style, and it was painters such as El Greco, Ingres and Cézanne who enabled him to construct his own formal language. In the same way, as a mature painter, Picasso would paraphrase old masters and thus add a new dimension to his late works. In 1946 an exhibition was shown at the Louvre, with pictures by Picasso side by side with paintings by Jacques-Louis David, Francisco de Goya and Diego Velázquez. Picasso's pictures – as one might have expected – stood the test, and from now on there was a touch of that typical post-war optimism in people's attitudes towards him: they were convinced that the new, as embodied in Picasso, would surpass the old.

His adaptation of "Las Meninas" (p. 84) of 17 August 1957 was one in a series of 44 variations on the same picture, all of which had taken shape as a result of a careful analysis of individual figures and the painting as a whole. It had been over half a century before, that Pablo had admired Velázquez's original of 1656 in the Prado. Picasso may have been inspired by the Spanish tradition of this picture, its worldwide fame, and the theme "painter and studio". But quite apart from that, if we consider that shortly before then he had been playing with different realities in his studio scenes and done so in a very complex fashion, then this picture acquires an enormous significance as a paradigm of artistic self-examination. Its exquisiteness combines object, subject and onlooker of the creative process within the same scene and relates them to one another: there is the model which is visible in the mirror at the back; the painter who is stepping aside from his painting; and the maids of honour who are following the painting of the picture. Velázquez is showing himself to the royal couple as a figure in the mirror, while at the same time giving an idea of the royal environment with the personalities that dominate it. This is what makes the painting a lasting document of artistic self-awareness.

Picasso, exempt from the dogma of central perspective, puts the painter more into the foreground and emphasizes him even more strongly. The real theme of the picture is Picasso himself and his self-examination. The question remains open whether the picture is mainly a quotation of Velázquez or rather of himself. Picasso without doubt has his place in any gallery of old masters. The crude outlines of the faces, the hurriedly drawn silhouettes and the sketchiness of the people on the right point to a technique that was to become typical of Picasso's latest phase, when he no longer sought to create any illusions, but reduced the language of his art to the simple abstract lines of children's drawings.

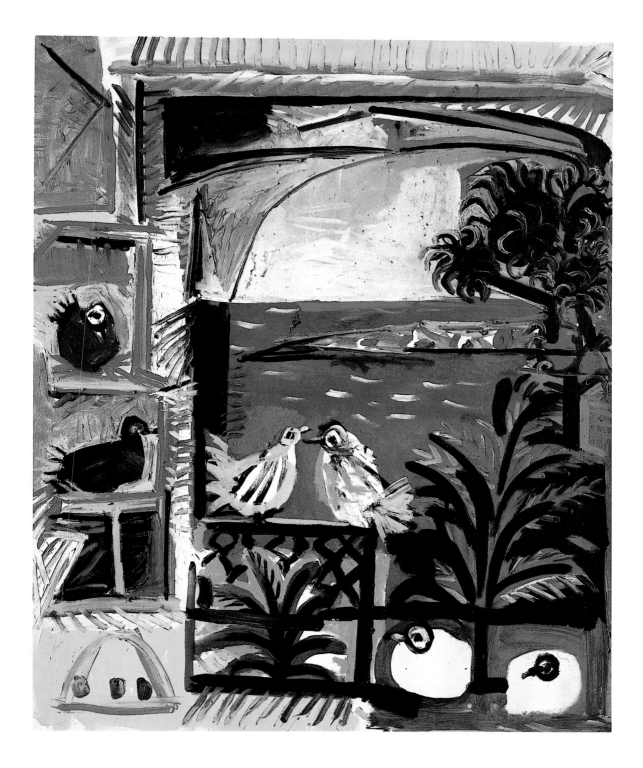

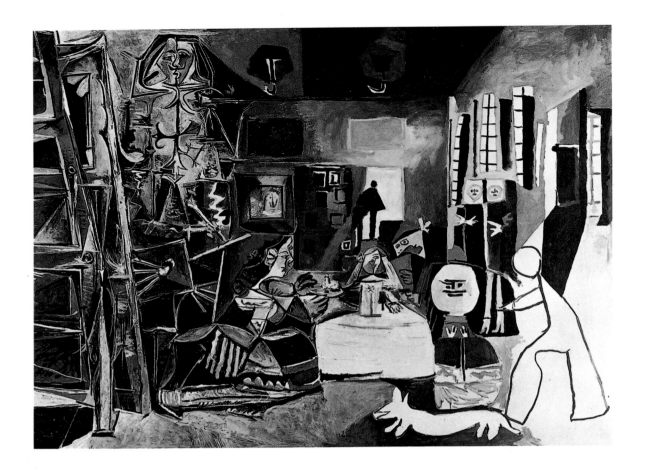

Las Meninas, after Velázquez, 1957
Oil on canvas, 76⅜ x 102⅜ in.
Museo Picasso, Barcelona

Diego Velázquez: Las Meninas, 1656
Oil on canvas, 125⅛ x 108⅝ in.
Museo del Prado, Madrid

Picasso loved his chaos more than anything else. His motley collection of all kinds of gadgets became more and more grotesque, there were more and more piles of pictures everywhere; in fact, it seemed that whenever a villa was full, he bought a new one. While he was painting "Meninas" he just moved on to the first floor of "La Californie", where, until then, he had allowed the pigeons of the neighbourhood to stay free of charge. They returned his kindness by serving as models, and that is why there is a whole series of pictures, painted at the same time as his "Meninas", in which we come across these pigeons. In this series Picasso gave a picturesque artistic rendering of his studio window and the view of the blue sea at Cannes. His "Doves" (p. 83) of September 1957 does no more than give a poetic depiction of the atmosphere of a gloriously sunny day, a painting without deep thoughts behind it and saying no more than what can be seen. Even a genius deserves the occasional break.

In 1958 "La Californie" had eventually stopped serving its purpose. It had enriched Cannes by giving it one more tourist attraction. There had been a constantly increasing stream of admirers and of people trying to catch a glimpse, so that it had become necessary to move house. Picasso

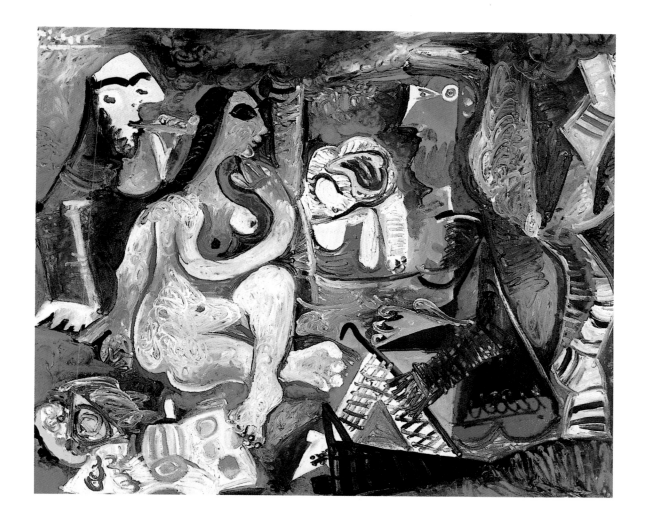

bought Chateau Vauvenargues, near Aix-en-Provence, a 14th century building with a view of Mont Sainte-Victoire, the hill that was associated with Cezánne who had lived in Aix. Picasso's move was reflected in his art with an increasing reduction in his range of colours to black, white and green.

But Picasso continued to enjoy painting whole series of pictures. His variations on Edouard Manet's "Luncheon on the Grass" (bottom right) also follow the theme "painter and model". Manet's original was regarded as scandalous in Paris in 1863, because the painter had dared to depict a nude female figure at a picnic in the woods, and – to make matters worse – accompanied by two fully-dressed gentlemen. Picasso's version of 1961 (p. 85) includes all the basic features of the classical original. And there are two themes which were to occur again and again until Picasso's death: the painter is smoking, and he is sitting fully dressed opposite the naked model.

Art itself had become the constantly recurring subject in Picasso's

Luncheon on the Grass, after Manet, 1961
Oil on canvas, 23 ⅝ x 28 ¾ in.
Galerie Rosengart, Lucerne

Edouard Manet: Luncheon on the Grass, 1863
Oil on canvas, 81 ⅞ x 104 ⅛ in.
Musée du Jeu de Paume, Paris

Head in Profile, 1963
Oil on canvas, 51 ⅛ x 38 ⅛ in.
Kunstsammlung Nordrhein-Westfalen,
Düsseldorf

"Braque said to me once: 'Deep down,
you've always loved classical beauty.' That
is true. It was then, and it still is. People
don't invent a new kind of beauty every
year." PICASSO

Female Nude and Smoker, 1968
Oil on canvas, 63 ¾ x 51 ⅛ in.
Galerie Rosengart, Lucerne

art, and it was as if Picasso was asking his colleague Manet how to paint painters. Again, we can see the demands of the public in the way Picasso was reflecting upon his own position, turning to authoritative, institutionalized artists such as Velázquez or Manet, and using his art as a means of objective discussion so that the public could follow his thoughts more easily. In fact, it was these variations on historically famous pictures which reached an extremely high level of publicity. Everything can be tested, verified and measured against a standard which had shaped Picasso and which Picasso himself had helped to set, i.e. the standard of artistic quality, or rather everybody's general consensus on it.

"Completing something means killing it, depriving it of life and soul." And with his later works Picasso did indeed remain true to his words and concentrated mainly on fragments and series of paintings. It was like a defiant attempt to bargain with Death and gain a few more hours from him, so that the word "completed" would not become applicable just yet. In the last years of his life painting had become an obsession with Picasso, and he would date each picture absolutely precisely, thus creating in his latest works a vast amount of similar paintings, crystallizations of individual moments of timeless happiness, knowing that in the end everything would be in vain.

Perhaps there was only one phenomenon that Picasso consistently refused to face up to. Occasionally, but subconsciously, it would come to the fore, domesticated in the form of a century-old symbolic language, as a skull, a candle, or a flower. The vitality of this renowned artist had enabled him to defy death for the length of almost two human lifetimes, but Art, his magic formula, had to become more and more emphatic to keep it at bay. With the pictures Picasso painted during the last years of his life, he did not look back on his life with self-satisfaction, and it is impossible to find in them an easily understandable common denominator that might sum up the whole of his art as a kind of heritage. Rather, it is a continuous fight against death in different forms.

In his "Cavalier with Pipe" (p. 78) of November 1968 Picasso shows a smoking figure dressed nostalgically like a gentleman. This was the sort of person Picasso identified with, and we find it again and again in his later works. A number of elements had become part of a constant pattern: Picasso's use of simplified imagery, the way he let the unpainted canvas shine through, his emphatic use of lines, and the sketchiness of the subject. "When I was as old as these children, I could draw like Raphael, but it took me a lifetime to learn to draw like them," Picasso explained in 1956. When children paint, they express their ideas rather than their perception, and when Picasso had recourse to such a technique, then that was his personal response to his approaching death. His style of painting showed that he was trying to avoid the issue, while at the same time reacting against an understanding of art that is based on orderliness and nature. Picasso's late works are an expression of his final refusal to fit into categories.

With his painting "Female Nude and Smoker" (p. 87) of the same year Picasso immortalized "La Belle et la Bête", the Beauty and the Beast. Again, there is a man at the centre who is smoking a pipe. He is bearded, haggard, and crippled, with his head bent forward; but beside him there

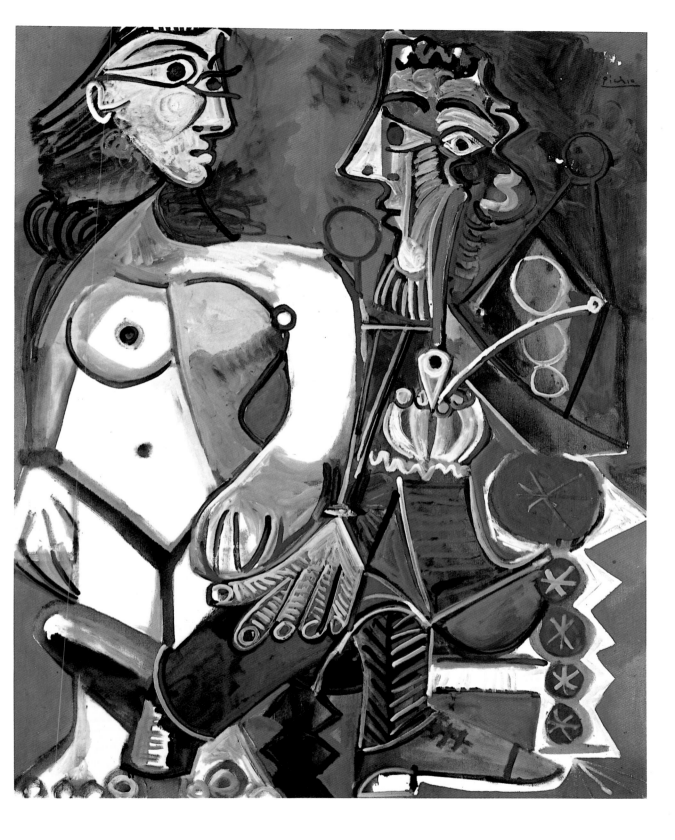

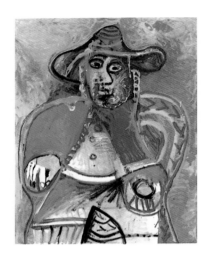

Seated Old Man, 1970/71
Oil on canvas, 56⅞ x 44⅞ in.
Musée Picasso, Paris

"This will do, won't it? What else should I
do? What could I possibly add? Everything
has been said." PICASSO

Rembrandt Figure and Eros, 1969
Oil on canvas, 63¾ x 51⅛ in.
Gift from the Galerie Rosengart to the City
of Lucerne

is a huge nude who is emphatically a body, a subject. The nude model had found her way back into Picasso's studio, but the way in which the two people's eyes meet and their hands touch shows that the act of painting had become a substitute for the act of sexual intercourse. Thus, by means of his art, Picasso revealed to us his current state of mind. In this picture the painter has become a voyeur, but his glances are no longer passionate or irresistible, and the model is now able not only to withstand it, but also to return it, as if she was accusing the artist of using the female body so frequently in his art. It seems that painting was the only relic of days gone by, because nothing else that used to give him satisfaction was still at his disposal — nothing except his art. Under the guise of the painter-and-model theme Picasso gave a personal justification for his indefatigable creativity: the picture was meant to prove that he was still alive.

The same smoker with a curly beard is also present in Picasso's "Rembrandt figure with Eros" (p. 89) of February 1969. Picasso used to take elements over from Rembrandt as early as forty years before, in his graphic cycle "Suite Vollard". And indeed there are a number of rather amazing similarities in the late works of both artists. Both artists began to turn in on themselves, concentrate on the theme "the artist" and paint only themselves, both developed a tendency towards psychological introspection in their self-portraits, and both withdrew into an artificial but unpretentious world. In both cases they were reacting to a public that was taking over their lives more and more. But whereas Picasso was trying to escape adulation, Rembrandt had to avoid bankruptcy. Eros has been given to the Rembrandt figure in Picasso's painting as an assistant, an artificial figure that makes both of them appear as if they were part of an artificial world. The painter himself has declared himself an element in his painting; he, too, has become an artificial person.

Pablo Picasso — Genius of the Century. The life he led served as an ideal example for the middle classes of this century and their professional ambitions. He was not alienated from his work, he was constantly willing to change, immensely successful and full of a never-ceasing vitality which lasted until he was very old indeed. And his life was always public. His art also set an example in that it always aimed at what was considered to be the happy medium, keeping the balance between the two extremes of permanent provocation, on the one hand, and continuous conformity, on the other. Again and again, Picasso would show clearly that he really knew his craft, and in doing so kept in touch with the evaluation criteria of a public that was firmly rooted in the world of everyday life. Picasso also set an example in the way he achieved the unity of art and life for himself. He achieved an unimaginable degree of popularity, piled up an enormous amount of wealth, and served as an object for the middle classes to demonstrate their liberal way of thinking and their expertise. Picasso allowed himself to be measured and quantified in terms of the only standards that were never questioned in the twentieth century: his production figures and his income. The extent to which he excelled in such matters made his genius appear all the more accessible to the general public, if only to put him on an even higher pedestal and to exalt him glowingly as a distant, unapproachable monument to what the human spirit can achieve.

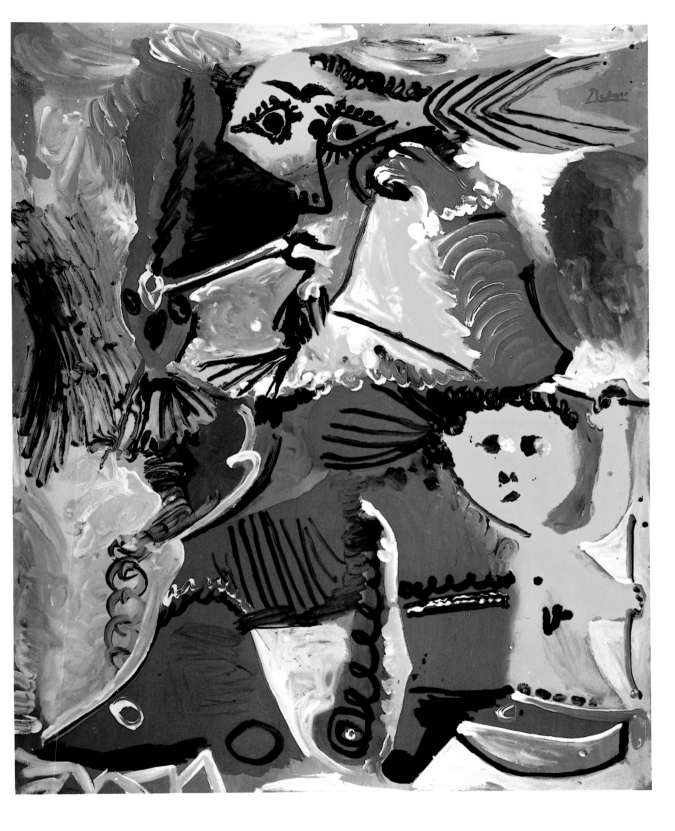

Pablo Picasso 1881 – 1973
His Life and Work

1881 Pablo Ruiz Picasso born 25 October in Málaga, Spain, first son of Don José Ruiz Blasco (1838 – 1913) and Doña Maria Picasso y Lopez (1855 – 1939). His father, a painter, comes from the north and teaches drawing at the local School of Fine Arts and Crafts "San Telmo". His mother is Andalusian.

1884 Birth of his first sister Lola (Dolorès).

1887 Birth of his second sister Concepción (Conchita).

1888/89 Helped by his father, he begins to paint.

1891 Picasso's father accepts a position as art teacher in La Coruña, where he moves with his family. Death of his sister Conchita. Starts local grammar school. Helps his father with paintings.

1892 Joins the School of Fine Arts in La Coruña and is taught by his father.

1894 Writes and illustrates journals. His father recognizes Pablo's extraordinary talent, hands him brush and palette and declares that he will never paint again.

1895 Moves to Barcelona and enrolls in the School of Fine Arts, where his father teaches. Skips the early classes and passes the entry examination for advanced classes with distinction.

Picasso's birthplace in Málaga, Plaza de la Merceded

1896 First studio in Barcelona. His first large "academic" oil painting, "The First Communion" (p. 6) appears in an exhibition.

1897 Paints "Science and Charity", his second large oil painting; it receives honourable mention in the national exhibition of fine art in Madrid and is awarded a gold medal in a competition at Málaga. His father's brothers send money so that Pablo can study in Madrid. Passes entrance examination for advanced courses at the Royal Academy of San Fernando in Madrid, but abandons it in the winter.

1898 Ill with scarlet fever and returns to Barcelona. Spends a long time with his friend Pallarés in the village of Horta de Ebro and regains his health. Sketches of landscapes.

1899 Returns to Barcelona. Begins to frequent Els Quatre Gats (The Four Cats) and makes friends with artists and intellectuals, meets among others the painters Junyer-Vidal, Nonell, Sunyer and Casagemas, the sculptor Hugué, the brothers de Soto, the poet Sabartés (later to be his secretary and lifelong close friend). Becomes acquainted with the work of Steinlen and Toulouse-Lautrec. Newspaper illustrations and first etchings.

Picasso in Paris, 1904. The words on the photograph are: "A mes chers amis Suzanne et Henri (Bloch)."

1900 Shares studio with Casagemas in Barcelona. Exhibits about 150 drawings at Quatre Gats. At the beginning of October Picasso and Casagemas leave for Paris and open a studio at the Montmartre. Visits art dealers, where he sees pictures by Cézanne, Toulouse-Lautrec, Degas, Bonnard et al. Art dealer Mañach (p. 9) offers him 150 Francs in exchange for pictures. Berthe Weill buys three pastels of bull-fights. Paints first Paris picture "Le Moulin de la Galette" (Guggenheim Museum, New York). Departs for Barcelona and Málaga with Casagemas in December.

1901 Casagemas commits suicide in Paris. Picasso moves to Madrid where he becomes co-editor of "Arte Joven". Second move to Paris in May. Installs himself in a studio at 130, Boulevard de Clichy. First exhibition at Gallerie Vollard; sells 15 pictures before the opening. Begins to sign his pictures simply "Picasso", his mother's name. Paints life in Paris ("The Absinthe Drinker", p. 11), with poverty, old age and loneliness as a more and more frequent theme. Uses almost exclusively blue and green. Beginning of his Blue Period.

1902 End of his contract with Mañach. Returns to Barcelona. Berthe Weill exhibition in Paris. Further development of blue monochrome paintings. Returns to Paris for third time in October. Lives with poet Max Jacob. Must confine activity to drawing because there is not enough money to buy canvas. Weill exhibition of "blue" canvases.

1903 Returns to Barcelona in January. Paints over fifty pictures within 14 months. "La Vie" (p. 14). Uses intensive shades of blue to depict the misery of physical weakness and old age.

Study for "Self-Portrait with a Palette", 1906
Pencil, 12 ⅜ x 17 ¼ in.
Musée Picasso, Paris

Picasso posing as a boxer in front of his studio at the Rue Schoelcher, Paris, around 1916

ethnographic museum. Beginning of period often called "Negro Period". Visits two Cézanne retrospectives. Meets Braque, whom Apollinaire brings to studio. Kahnweiler is enthusiastic about his "Demoiselles" and becomes his only dealer.

1908 Paints numerous "African" nudes, influenced by "Negro sculpture". Spends summer with Fernande at La Rue des Bois, north of Paris. Paints figures and landscapes there. Braque shows his first cubist pictures, his L'Estaque works, at Kahnweiler's gallery. In November he gives large banquet in his studio, honouring Henri Rousseau, one of whose paintings he has bought recently.

1909 Paints "Bread and Fruit Dish on a Table" (p. 36). Beginning of his „analytical" cubism (i.e. gives up central perspective, splits up forms in facet-like stereometric shapes). In May he takes Fernande to see parents and friends in Barcelona. Goes on to Horta de Ebro, where he has the most productive period of his career: land- and townscapes ("The Reservoir, Horta", private collection, New York) in analytical cubist style. Portraits of Fernande ("Woman with Pears", p. 39). Moves to 11, Boulevard de Clichy, near Place Pigalle in September, next door to Braque's place. Sculpture of "Fernande" (p. 46); still lives. First exhibition in Germany (Galerie Thannhausen, Munich).

1910 Completes his famous cubist portraits of the art dealers Vollard (p. 38) and Kahnweiler (Art Institute, Chicago) as well as the art critic Uhde (private collection). Spends summer with Fernande in Cadaqués near Barcelona, where they are joined by Derain and his wife.

1911 First New York exhibitions. Spends summer with Fernande and Braque in Céret (Pyrenees). Introduces printed letters in his pictures for the first time. Has to hand two Iberian sculptures back to the Louvre, because he has unwittingly bought them from a thief. Crisis in his relationship with Fernande; enters a liaison with Eva Gouel (Marcelle Humbert), whom he calls "Ma Jolie". Paints "Mandolin Player" (Musée Picasso, Paris).

1912 First construction in sheet metal and wire. First collage ("Still Life with Chair Caning", Musée Picasso, Paris), with piece of oil-cloth imitating a cane pattern. Takes Eva to Céret, Avignon and Sorgues, where they meet Braque. Makes first "papiers collés" (pasted paper work): collages of newspaper headlines, labels, advertising slogans with charcoal drawings on paper. Moves from Montmartre to Montparnasse in September. New address: 242, Boulevard Raspail. Three-year contract with Kahnweiler.

1913 Spends spring with Eva in Céret, where they meet Braque and Derain. His father's death in Barcelona. His "papier collés"

Picasso, 1917

lead to synthetic cubism, with large, schematic patterning, such as "The Guitar", (p. 41). Eva and Pablo fall ill, return to Paris and move to 5, Rue Schoelcher.

1914 "Family of Saltimbanques" (p. 25) sells for 11.500 Francs at an auction. Spends June with Eva in Avignon; meets Braque and Derain. Paints "pointillist" pictures. Braque and Derain are drafted into the army at the beginning of the war. Kahnweiler goes to Italy, his gallery is confiscated. Picasso's pictures become sombre.

1915 Realistic pencil drawings of Max Jacob and Vollard. Paints "Harlequin" (p. 43).

1916 Cocteau brings the Russian Impressario Diaghilev and the composer Satie to meet Picasso and asks him to design the decor for "Parade", a ballet to be performed by the Ballet Russe. Moves to 22, Rue Victor Hugo in Montrouge.

1917 Travels to Rome with Cocteau and spends his time with Diaghilev's ballet company. Works on decor for "Parade". Meets Stravinsky and the Russian dancer Olga Koklova. Visits Naples and Pompey. Accompanies ballet group to Madrid and Barcelona because of Olga. Olga stays with him. Back to Montrouge in November. Paints "pointillist" pictures.

1918 Contacts with high society through the ballet result in a change of lifestyle. Rosenberg becomes his new agent. Marries Olga. Honeymoon in Biarritz. Apollinaire's

1904 Picasso's final move to Paris. Studio at 13, Rue Ravignan (until 1909), called "Bateau-Lavoir". Meets Fernande Olivier who is to be his mistress for the next seven years. Makes etching "The Frugal Repast" (p. 28). Pays frequent visits to the Circus Médrano (where he gets ideas for his pictures of jugglers and circus artistes) and the Lapin Agile. End of Blue Period.

1905 Meets Apollinaire and Leo and Gertrude Stein. Frequently paints circus themes, such as "The Family of Saltimbanques" (p. 25). Beginning of Rose Period. Summer holiday in Schoorl, Holland. First sculptures. Series of etchings called "The Acrobats".

1906 Picasso is impressed by exhibition of Iberian sculptures at the Louvre. Meets Matisse, Derain and the art dealer Kahnweiler. Vollard buys most of his "rose" pictures, thus for the first time enabling Picasso to lead a life free of financial worries. Takes Fernande to his parents in Barcelona, then to Gosol in the north of Catalonia, where he paints "La Toilette" (p. 27). Influence of Iberian sculptures on "Portrait of Gertrude Stein" (Metropolitan Museum of Art, New York) and "Self-Portrait with Palette" (p. 2)

1907 "Self-portrait" (p. 32). With numerous studies and variations, he prepares his large canvas "Les Demoiselles d'Avignon" (p. 34-5), which he finishes in July: his first cubist painting, even before the beginning of cubism. Sees African sculptures at

Olga Picasso, 1923
Oil on canvas, 51 ⅛ x 38 ⅛ in.
Private collection

1924 Several large still lives in the decorative cubist mode. Ballet decor again. Holiday with Olga and Paul in Juan-les-Pins. Portrait of "Paul as Harlequin" (p. 50). Publication by Breton of "Manifeste du Surréalisme".

1925 Accompanies ballet company and Olga and Paul to Monte Carlo in spring. Paints "The Dance" (Tate Gallery, London), with first signs of tension in his marriage. Summer in Juan-les-Pins, where he paints "Studio with Plaster Head" (p. 57) using Paul's puppets as props. Contributes to first surrealist exhibition in November.

1926 Series of assemblages on Guitar theme, using objects such as a shirt, a floor-cloth, nails and string. Holidays in Juan-les-Pins and Antibes. Takes Olga to Barcelona in October.

1927 Meets seventeen-year old Marie-Thérèse Walter in front of Galerie Lafayette. She becomes his mistress shortly afterwards. Gris's death. Series of pen-and-ink drawings of aggressively sexual bathing women.

1928 First sculpture since 1914. Meets sculptor Gonzalez. Summer in Dinard with Paul and Olga. Keeps meeting Marie-Thérèse secretly. Small paintings with intensive colours and schematic forms. Several wire constructions as studies for Apollinaire monument.

1929 Works on sculptures and wire constructions with Gonzalez. Series of aggressive paintings with women's heads signals marriage crisis. Summer in Dinard.

1930 Metal sculptures in Gonzalez's studio. Paints "Crucifixion" (Musée Picasso, Paris). Buys Chateau Boisgeloup near Gisors, north of Paris. Holiday in Juan-les-Pins. 30 etchings to illustrate Ovid's "Metamorphoses" Installs Marie-Thérèse in flat in 44, Rue la Boétie.

1931 Sculpture "Head of a Woman" (p. 47) using colanders. Sculptor's studio at Boisgeloup. Series of sculptures of large heads and busts. Holiday in Juan-les-Pins. Cycles of etchings are exhibited at Skira's and Vollard's.

1932 Series of seated or recumbent blonde women, for which the model is Marie-Thérèse. Major retrospective in Paris (236 works) and Zurich. Christian Zervos publishes first Picasso catalogue. (34 have been published up to 1985).

1933 Etchings on the theme of the "Sculptor's Studio" for the "Suite Vollard" (p. 29) and studies on the "Minotaur" theme. Summer holiday in Cannes with Olga and Paul, then car trip to Barcelona where he meets old friends. Tries in vain to prevent a book of memoirs by Fernande Olivier from being

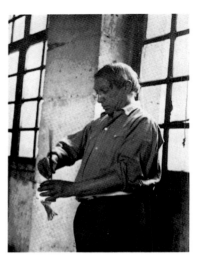

Picasso working on "Guernica", 1937

death. The Picasso occupy two floors in a block of flats at 23, Rue La Boétie.

1919 Meets Miró and buys one of his pictures. Spends three weeks in London with the Ballet Russe. Begins to work on decor for "Le Tricorne"; drawings of the dancers. Spends summer in Saint-Raphaël on the Riviera with Olga. Paints "Sleeping Peasants" (p. 52) and cubist still lives.

1920 Begins to work on decor for Stravinsky's ballet "Pulcinella". Kahnweiler returns from exile. Spends summer in Saint-Raphaël and Juan-les-Pins with Olga. Gouaches with themes from the Commedia dell'Arte.

1921 Birth of his son Paul (Paolo). Recurrent "Mother and Child" theme. Further sketches for ballet decors. Uhde's and Kahnweiler's collections, which were confiscated by the French during the war, are auctioned. Spends summer at Fontainebleau with Olga. Paints "Three Musicians" (p. 56) and several compositions with monumental figures.

1922 The collector Doucet buys the "Demoiselles d'Avignon" (p. 35) for 25.000 Francs. Spends summer in Dinard, Brittany, with Olga and Paul, where he paints "Woman Running on the Beach" (p. 53). Drop curtain for Cocteau's "Antigone" in winter.

1923 Harlequin portraits in neo-classicist style. Summer at Cap d'Antibes. A visit from his mother Maria. Paints "The Pipes of Pan" (p. 55) and studies of bathers. Portraits of Olga and Paul in Paris.

published, for fear of Olga's jealousy.

1934 More etchings. Sculptures at Boisgeloup. Trip to Spain with Olga and Paul to see bull-fights in San Sebastian, Madrid, Toledo and Barcelona. Numerous works on the bull-fight theme using all his techniques.

1935 Paints "Interior with a Girl Drawing" (p. 60). No more paintings between May 1935 and February 1936. Etches "Minotauromachy" (p. 30), his most important cycle. Marie-Thérèse is pregnant; separates from Olga and Paul; divorce has to be postponed because of problems with the distribution of their property. Picasso: "The worst time of my life." 5 October: birth of Picasso's second child, Maria de la Concepción, called Maya. Invites old friend Sabartés to become his secretary.

1936 Touring exhibition of his pictures in Barcelona, Bilbao, Madrid. Travels secretly to Juan-les-Pins with Marie-Thérèse and Maya. Starts working on Minotaur theme. 18 July: beginning of Spanish civil war. Opposes Franco; Republicans recognize his support and make him director of Prado Museum. Spends August in Mougins, near Cannes. Meets Dora Maar, Yugoslavian photographer. Leaves Olga at Boisgeloup in autumn and moves into Vollard's house. Marie-Thérèse follows with Maya.

1937 Etches "The Dream and Lie of Franco". Moves into new studio at 7, Rue des Grands Augustins. After the German air attack on Guernica on 26 April he paints his gigantic mural for the Spanish pavilion at the Paris world exhibition: "Guernica" (p. 68 – 9). In summer portrait of Dora Maar (p. 63) at

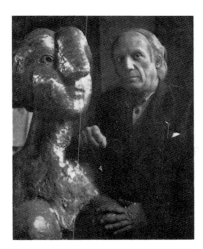

Picasso in his studio at the Rue des Grands Augustins, 1944

Picasso drawing with a torch. Vallauris, 1949

wearing a striped blouse (Hahn Collection, New York).

1943 Assemblage "Head of a Bull" (p. 48). Sculptures. Meets young woman painter Françoise Gilot who visits him frequently at his studio. Resumes painting.

1944 Max Jacob is arrested and dies in a concentration camp. Large sculpture "Man with Sheep" (p. 48). Readings are held of "Desire Caught by the Tail", with Albert Camus, Simone de Beauvoir, Jean-Paul Sartre, Raymond Queneau et al. taking part. Joins Communist Party after liberation of Paris. Contributes to exhibition at the Salon d'Automne with 74 paintings.

1945 Paints "The Charnel House" (p. 75) as a pendant to "Guernica". Series of still lives. Spends July in Antibes with Dora. Rents room for Françoise in the vicinity, but she goes to Brittany. Buys Dora a house in the village of Ménerbes and pays for it with a still life. Begins working with lithography at Fernand Mourlot's Paris studio, producing 200 works by 1949.

Mougins. Meets Paul Klee in Berne. Museum of Modern Art in New York buys "Les Demoiselles d'Avignon" for $ 24.000.

1938 Paints several pictures of Maya with toys (p. 71). Makes a wallsize collage "Women at their Toilet" (Musée Picasso, Paris). Spends summer in Mougins with Dora. Severe attack of sciatica in winter.

1939 Death of Picasso's mother in Barcelona. Paints Marie-Thérèse and Dora in the same pose and on the same day. Spends July in Antibes with Dora and Sabartés. Death of Vollard. Paints "Night Fishing at Antibes" (p. 74), then Dora with bicycle and ice-cream. Takes Dora and Sabartés to Royan at the beginning of the war, where Marie-Thérèse and Maya join them. Stays there, with interruptions, until August 1940. Major retrospective in New York, with 344 works, including "Guernica".

1940 Commutes between Royan and Paris. In Royan he paints "Woman Dressing Her Hair" (Smith Collection, New York). German troops invade Belgium and France, occupying Royan in June. Returns to Paris. Gives up flat in Rue La Boétie and moves into studio at Rue des Grands Augustins. Hands out photos of "Guernica" to German officers. When asked, "Did you do this?" he replies, "No, you did."

1941 Writes surrealist farce, "Desire Caught by the Tail". Marie-Thérèse and Maya move to Boulevard Henri IV; Picasso visits them at three weekends. He is not allowed to leave Paris to work at Boisgeloup. Provisional scultptor's studio in bathroom.

1942 Paints "Still Life with Steer's Skull" (p. 73). He is attacked by Vlaminck in a magazine article. "Portrait of Dora Maar"

1946 Takes Françoise to Nice to see Matisse. Françoise becomes his mistress and moves in with him. Makes paintings and lithographs of her. Takes her to Ménerbes in July, where they stay at Dora's house. Françoise is pregnant. Picasso is given permission to work at the museum of Antibes and after four months donates numerous pictures to it. The museum is soon renamed Musée Picasso.

1947 Lithographs at Mourlot's workshop. Gives ten pictures to the Musée National d'Art Moderne in Paris. On 15 May Françoise gives birth to Claude, Picasso's third child. Begins to make ceramics at the Madoura pottery, the workshop of the Ramiés and creates about 2000 pieces between 1947 and 1948 (p. 76/77).

The master's left hand, 1947

1948 Moves to La Galloise, a villa in Vallauris. Takes part in Congress of Intellectuals for Peace in Wroclaw, Poland, where he also visits Cracow and Auschwitz. Ceramics exhibition in Paris. Portraits of Françoise.

1949 "Dove" lithograph becomes motif for poster announcing World Peace Congress in Paris (p. 64). 19 April: birth of Picasso's fourth child, Paloma (Spanish word for "dove", named after poster motif). Rents old perfume factory as a studio and store-room for ceramics. More sculptures.

1950 Paints "Women on the Banks of the Seine, after Courbet" (Kunstmuseum, Basle). Sculptures "The Nanny-Goat" and "Woman with Baby Carriage", made from junk and cast in bronze (p. 48,49). Travels to World Peace Conference in Sheffield. Receives Lenin Peace Prize. Becomes honorary citizen of Vallauris.

1951 Paints "Massacre in Korea" in protest at the American invasion. Gives up flat in Rue La Boétie and moves to 9, Rue Gay-Lussac. Ceramics in Vallauris. Sculpture "The Monkey and Her Baby" (p. 48). Retrospective in Tokyo.

1952 Two large mural paintings called "War" and "Peace" for the new Temple of Peace in Vallauris. Relationship with Françoise deteriorates.

1953 Works in Vallauris. Major exhibitions in Rome, Lyons, Milan and Saô Paulo. Portrait of Stalin on the occasion of his death is received with disapproval by Communist Party. Series of busts and heads of Françoise. Takes Maya and Paul to Perpignan, where he meets Jacqueline Roque. Françoise and children move to Rue Gay-Lussac.

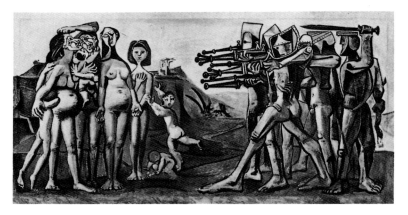

Massacre in Korea, 1951
Oil on plywood, 43 ⅛ x 82 ½ in.
Musée Picasso, Paris

Aix-en-Provence, where he works occasionally between 1959 and 1961.

1959 Paints at Chateau Vauvenargues. Starts on variations of Manet's "Luncheon on the Grass" (p. 85). First experiments with lino-cuts.

1960 Retrospective at Tate Gallery, London, with 270 works. Designs large-scale sheet-metal sculpture, constructing maquettes from cardboard.

1961 Marries Jacqueline Roque at Vallauris. Moves to Notre Dame de Vie, a villa near Cannes. Celebrates 80th birthday in Vallauris. Works with painted and corrugated sheet-metal.

1962 Over 70 portraits of Jacqueline. Awarded Lenin Peace Prize for second time. Designs decor for Paris ballet. Numerous lino-cuts.

1963 Variations of Jacqueline's portrait. Series of pictures on "Painter and Model" theme. Opening of Museo Picasso in Barcelona. Death of Braque and Cocteau.

1954 Meets Sylvette David, a twenty-year old girl who poses for portraits. More portraits of Jacqueline. Spends some time in Vallauris with Françoise and children, as well as with Jacqueline. Takes Maya and Paul to Perpignan. Separates from Françoise, and Jacqueline moves in with him. Death of Matisse (Picasso: "All things considered, there's only Matisse"). Begins series of paintings based on Delacroix's "Women of Algiers".

1955 Olga Picasso dies in Cannes. Sojourn with Jacqueline in Provence. Major retrospective in Paris (then in Munich, Cologne, Hamburg). Filming of Clouzot's "Le Mystère Picasso". Buys La Californie, a villa in Cannes. Portraits of Jacqueline.

1956 Series of studio pictures, including "The Studio 'La Californie' at Cannes" (p. 80) and "Jacqueline in the Studio (p. 81). Large bronze sculpture "The Bathers" (p. 49), after wooden assemblages. Celebrates 75th birthday with potters in Vallauris. Letter of protest to Communist Party about Russian intervention in Hungary.

1957 Exhibitions in New York, Chicago and Philadelphia. At La Californie he works on 40 variations of Velázquez's "Las Meninas" (p. 84). He is asked to paint mural for new UNESCO building in Paris.

1958 Completes UNESCO mural "The Fall of Icarus". Buys Chateau Vauvenargues near

"In the world of art it was this man who formed our age; our century is that of Pablo Picasso. There were, of course, other great painters and sculptors in our period; but it was Pablo Picasso, more than anyone else, who showed us the way, not just in painting, but also sculpture and the graphic arts. This is how he formed our visible world." DANIEL HENRY KAHNWEILER

Picasso with his children Paloma and Claude at Vallauris, 1953

At a bull-fight in Vallauris, 1955
Picasso is sitting between Jacqueline and Jean Cocteau. Behind him his children Maya (with guitar), between Paloma and Claude.

Picasso's art dealer Daniel Henry Kahnweiler, 1957
Crayon on transfer paper, 25 ¼ x 19 ¼ in.

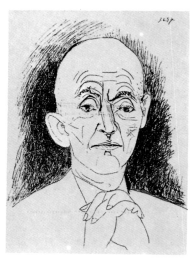

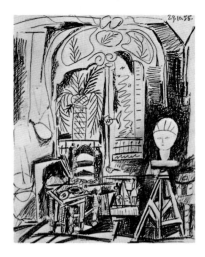

Picasso's Studio "La Californie" at Cannes, 1955
Pencil, 25¾ x 19⅞ in.

Seated Man (Self-Portrait), 1965
Oil on canvas, 39¼ x 31⅝ in.
Jacqueline Picasso Collection, Mougins

1964 Publication of Françoise Gilot's memoirs "Life with Picasso" leads to a rift between him and their children Claude and Paloma. Exhibitions in Canada and Japan. Completes model for giant sculpture "Head of a Woman" to appear in Chicago's new civic centre in 1967.

1965 Series of paintings on the "Painter and Model" theme, landscapes, stomach operation in Neuilly-sur-Seine; last trip to Paris.

1966 Resumes drawing and painting, then also reprographics in summer. Major retrospective exhibition at Grand Palais and Petit Palais in Paris: over 700 works including many sculptures owned by himself.

1967 Refuses French Legion of Honour. Evicted from studio in Rue des Grands Augustins. Exhibitions in London and New York.

1968 Death of Sabartés. Picasso gives Museum in Barcelona 58 pictures from the series "Las Meninas". Makes 347 etchings within seven months.

1969 Numerous paintings: faces, couples, still lives, nude figures, smokers (p. 89).

1970 Picasso family in Barcelona donates all paintings and sculptures in its possession to Museo Picasso, Barcelona (early works from Barcelona and La Coruña).

1971 Celebrates his 90th birthday.

"Each new picture by Picasso is met by the public with indignation, and then their amazement changes into admiration."
AMBROISE VOLLARD

"You expect me to tell you: what is art? If I knew, I would keep my knowledge to myself."
PICASSO

1972 Draws series of self-portraits. Donates wire construction of 1928 (p. 47) to Museum of Modern Art, New York.

1973 Dies at Mougin on 8 April and is buried in the grounds of Chateau Vauvenargues on 10 April.

1979 Picasso's heirs pay their death duties in the form of a large number of works from Picasso's private collection, which become the property of the French government. Exhibition of these works at the Grand Palais in Paris, later to be renamed Musée Picasso.

1980 Largest-ever Picasso retrospective on the occasion of the 50th anniversary of the opening of the Museum of Modern Art, New York.

1985 Opening of the Musée Picasso at the Hôtel Salé in Paris, with 203 paintings, 191 sculptures, 85 ceramics, and over 3000 drawings and graphics.

Bibliography

Bibliographies
Gaya Nuño, Juan Antonio: Bibliografía
critica y antológica de Picasso. San
Juan 1966
Kibbey, Ray Anne: Picasso. A Compre-
hensive Bibliography. New York 1977

Books by Picasso
Picasso, Pablo: Wort und Bekenntnis. Die
gesamten Zeugnisse und Dichtungen.
Zürich 1954
Vier kleine Mädchen. Ein Spiel in sechs
Akten. Zürich 1970
Worte und Gedanken von Pablo Picasso.
Basel 1967/68
Worte des Malers Pablo Picasso. Berlin
1970

Art Catalogues
Bloch, Georges: Pablo Picasso. Katalog
des graphischen Werkes. 4 Bde. Bern
1968–1979
Daix, Pierre und Georges Boudaille: Pi-
casso. Blaue und Rosa Periode. Mün-
chen 1966
Daix, Pierre und Joan Rosselet: The Cu-
bist Years 1907–1916. Boston 1979
(frz. Ausgabe: Neuchâtel 1979)
Geiser, Bernhard: Picasso. Peintre-Gra-
veur. 2 Bde. Bern 1933 u. 1968
Goeppert, Sebastian u. a.: Pablo Picasso,
catalogue raisonné des livres illustrés.
Genf 1983
Mourlot, Fernand: Picasso Lithographe.
4 Bde. Monte Carlo 1949–1964
Spies, Werner: Picasso. Das plastische
Werk. Stuttgart 1971, [2]1983
Zervos, Christian: Pablo Picasso [Werk-
verzeichnis der Gemälde; Skulpturen
und Keramiken nicht vollständig]. Bd.
I–XXXIII (wird fortgesetzt). Paris 1932–
1978 (»Cahiers d'Art«)

Drawings and Graphics
Bollinger, Hans und Bernhard Geiser:
Pablo Picasso. Das graphische Werk
(1899–1954). Stuttgart 1955
Bollinger, Hans und Kurt Leonhard: Pablo
Picasso. Das graphische Werk (1955–
1965). Stuttgart 1966
Jardot, Maurice: Pablo Picasso. Zeich-
nungen. Stuttgart 1959
Rau, Bernd: Pablo Picasso: Das graphi-
sche Werk. Stuttgart 1974
Zervos, Christian: Dessins de Picasso
1892–1948. Paris 1949

Sculptures
Fairweather, Sally: Picasso's Concrete
Sculptures. New York 1982
Johnson, Ron: The Early Sculpture of Pi-
casso. New York 1976

Kahnweiler, Daniel-Henry: Les Sculptu-
res de Picasso. Paris 1948
Penrose, Roland und Alicia Legg: The
Sculpture of Picasso. New York 1967

Ceramics
Kahnweiler, Daniel-Henry: Picasso. Ke-
ramik. Hannover 1957, [2]1970
Ramié, Georges: Céramiques de Picasso.
Paris 1975 (engl. Ausgabe: New York
1976)

Posters
Czwiklitzer, Christophe: Picasso. Plaka-
te. Basel 1972 (Taschenbuchausgabe:
München 1981)

Memoires
Brassaï: Gespräche mit Picasso. Reinbek
1966
Gilot, Françoise und Carlton Lake: Leben
mit Picasso. München 1965
Olivier, Fernande: Neun Jahre mit Picas-
so. Zürich 1957
Parmelin, Hélène: Picasso sagt . . . Mün-
chen 1966
Penrose, Roland: Picasso und seine Zeit.
Ein Fotobuch. Zürich 1957
Sabartés, Jaime: Gespräche und Erinne-
rungen. Zürich 1956
Stein, Gertrude: Picasso. Erinnerungen.
Zürich 1975

Biographies, Monographs,
Dissertations, Catalogues
Barr, Alfred H.: Picasso. Fifty Years of His
Art. New York 1946, [4]1974
Baumann, Felix Andreas: Pablo Picasso.
Leben und Werk. Stuttgart 1976
Berger, John: Glanz und Elend des Malers
Pablo Picasso. Reinbek 1973
Blunt, Anthony und Phoebe Pool: Picas-
so. The Formative Years. A Study of His
Sources. London 1962
Boeck, Wilhelm: Pablo Picasso. Stuttgart
1955
Cabanne, Pierre: Le Siècle de Picasso.
2 Bde. Paris 1975
Cassou, Jean (Hg.): Picasso. Köln 1975
Cirlot, Juan-Eduardo: Pablo Picasso. Das
Jugendwerk eines Genies. Köln 1972
Daix, Pierre: La Vie du Peintre Pablo Pi-
casso. Paris 1977
Dufour, Pierre: Picasso 1950–1968.
Genf 1969
Elgar, Frank und Robert Maillard: Picas-
so. München, Zürich 1956
Gallwitz, Klaus: Picasso laureatus. Sein
malerisches Werk seit 1945. Luzern,
Frankfurt am Main 1971, [2]1985
Gedo, Mary M.: Picasso. Art as Autobio-
graphy. Chicago 1980

Golding, John: Picasso 1881–1973. Lon-
don 1974
Imdahl, Max: Picassos Guernica. Frank-
furt am Main 1985
Janis, Harriet und Sidney: Picasso. The
Recent Years (1939–1946). New York
1946
Kahnweiler, Daniel-Henry: Der Weg
zum Kubismus. Stuttgart 1958
Leymarie, Jean und Jean-Luc Daval: Pi-
casso. Metamorphosen. Genf 1971
O'Brian, Patrick: Pablo Picasso. Eine Bio-
graphie. Hamburg 1976
Palau y Fabre, Josep: Picasso. Kindheit
und Jugend eines Genies: 1881–1907.
München 1981
Penrose, Roland: Picasso. Leben und
Werk. München 1958 (erweiterte Neu-
ausgabe: München 1981)
Picasso-Museum Paris. Bestandskatalog
der Gemälde, Papiers collés, Reliefbil-
der, Skulpturen und Keramiken. Mün-
chen 1985
Raynal, Maurice: Picasso. Genf 1953
Rosenblum, Robert: Der Kubismus und
die Kunst des 20. Jahrhunderts. Stutt-
gart 1960
Rubin, William (Hg.): Picasso in the Col-
lection of the Museum of Modern Art.
New York 1972
Pablo Picasso: Retrospektive im Mu-
seum of Modern Art, New York. Mün-
chen 1980
Wiegand, Wilfried: Pablo Picasso in
Selbstzeugnissen und Bilddokumen-
ten. Reinbek 1973

The author wishes to express his gratitude
to the museums, collectors and archives
who allowed works from their collections
to be reproduced in this book. He would
also like to thank the photographers and
photographic libraries who provided
photographs. Special acknowledgement is
made to the Galerie Rosengart, Lucerne,
and André Rosselet, Neuchâtel. A number
of pictures have been reproduced from:
Edition Ides et Calendes, Neuchâtel.
Alexander Koch Archive, Munich. Gruppo
Editoriale Fabbri, Milan. Editions d'Art
Albert Skira, Geneva. André Held,
Ecublens. Paul Bernard, Paris. John Miller,
New York. Matthias Buck, Munich. Ingo F.
Walther, Alling. Walther & Walther Verlag,
Alling. The majority of Picasso quotations
are English translations from "Wort und
Bekenntnis", published by Arche Verlag,
Zurich, and "Picasso sagt ..." by Hélène
Parmelin, published by Verlag Kurt Desch,
Munich.